709.2/SEG

George Segal

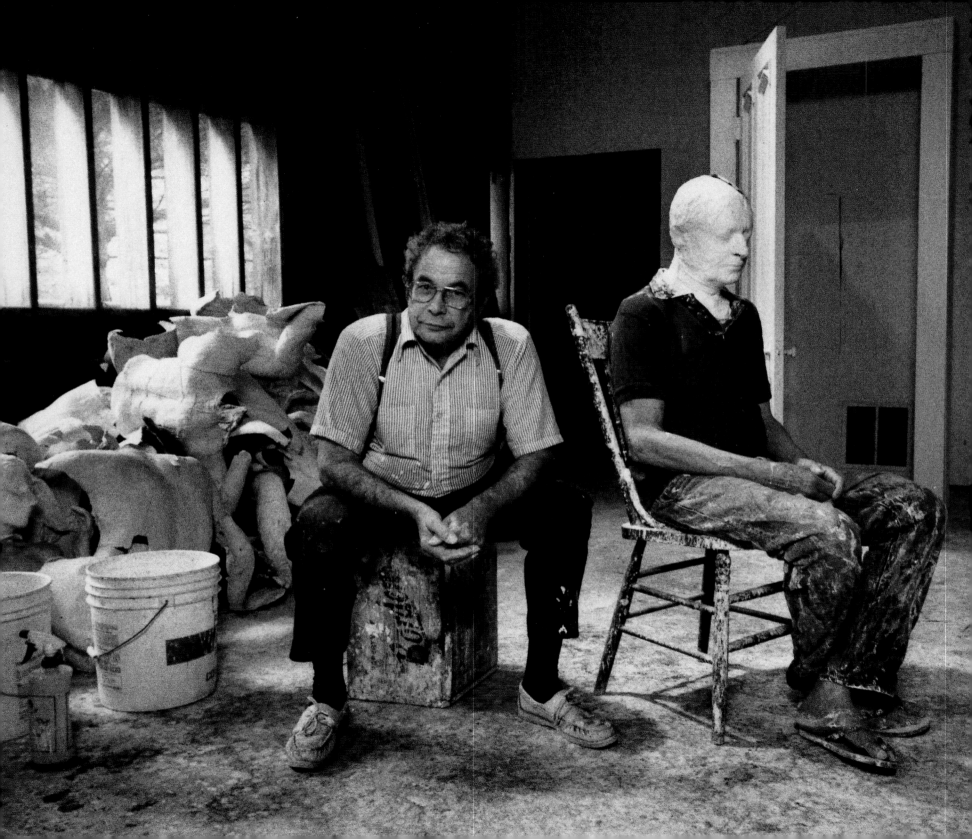

George Segal

Bronze

Segal Casting by Carroll Janis

George Segal's Bronzes by Joan Pachner

Mitchell-Innes & Nash New York
The George and Helen Segal Foundation
Carroll Janis Inc. New York

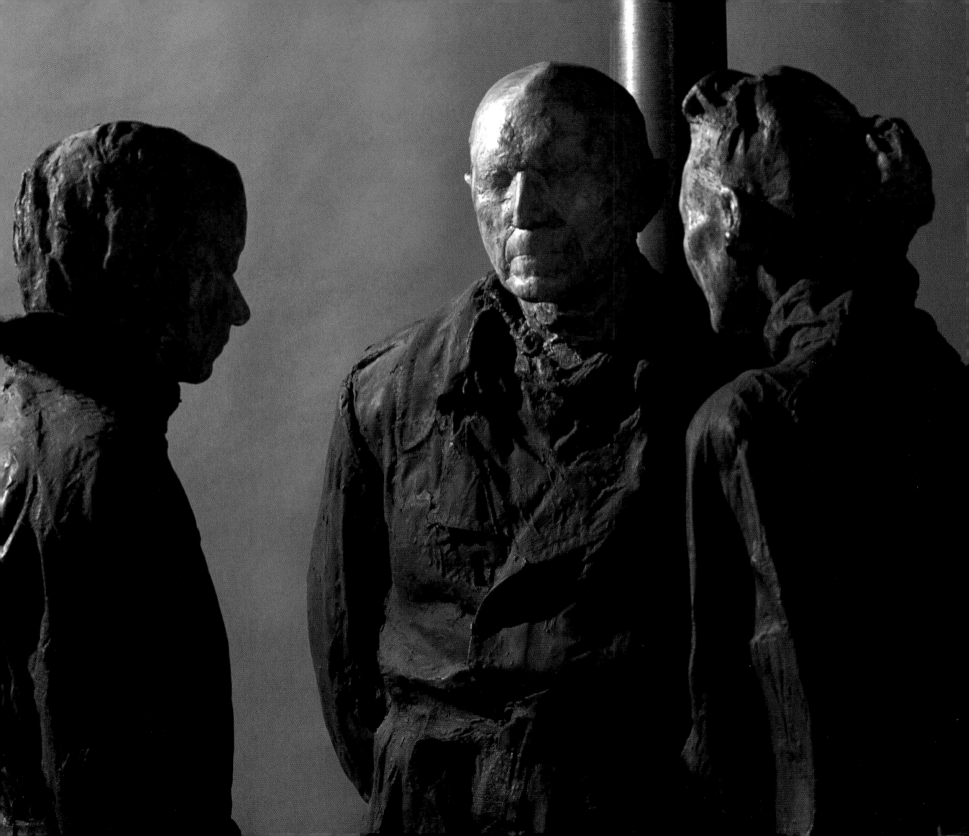

Segal Casting

George Segal's first figure sculptures, from 1958, were intensely expressionist. These early works were constructed with plaster and burlap over an armature of chicken wire. A few years later the artist made a breakthrough decision to cast his own body. This entailed casting himself one section at a time and reassembling the parts into a whole figure. He then included the chair he was sitting on and the table before him in the completed work *Man Seated At Table*, 1961. Next he turned to relatives and friends to people his works—not as portraits, but as individuals cast in more universal roles. It can be observed that as soon as he began live casting all the essential elements of his new style emerged: an environmental sculpture with cast plaster figures placed against real objects.

In 1961 the artist began to use gauze embedded with plaster—a new medical product for setting broken bones—which allowed him to model a more delicate and naunced surface. In Segal's method of direct casting, the finer detail remains on the inside of the plaster mold. But initially he preferred to use the rougher, more evocative exterior of the mold. He would then rework this exterior by hand with wet plaster, sometimes even painting it. Segal liked to work with the indelible imprint, as much psychological as physical, left by the sitter in his plasters, and believed his sculptures could capture something of the essence or spirit of the individual.

In the late-1960s Segal began double-casting—taking a second cast from inside the mold of the original cast. This process brought finer detail to the surface and was part of his evolution to a more naturalizing image. By the 1980s Segal was using this technique when he began making his bronze work for outdoor installation. All his bronzes were made from finished plasters, although he selected only a limited number for the process. The patinas for the bronzes were often white (like the plasters) as in the gently day-dreaming *Woman in Armchair*, 1994, or in *Street Crossing*, 1992, the seven-figure work which can be seen as an American response to Giacometti's *Place*. But Segal also used a variety of other patinas as in the colored light of *Depression Breadline*, 1991, for the F.D.R Memorial in Washington DC, the deep blue-black in the monumental six-figure group *Rush Hour*, 1983, or the grisaille in *Chance Meeting*, 1989, a patina which creates a *chiaroscuro* over the three figures waiting under a street sign.

Segal's plaster sculpture presents an existential situation; the surrogate figure, more fragile and removed from reality when set next to the real object. The bronzes appear to reverse this idea by asserting the strength and permanence of the human figure within the surrounding environment.

Carroll Janis
New York, 2003

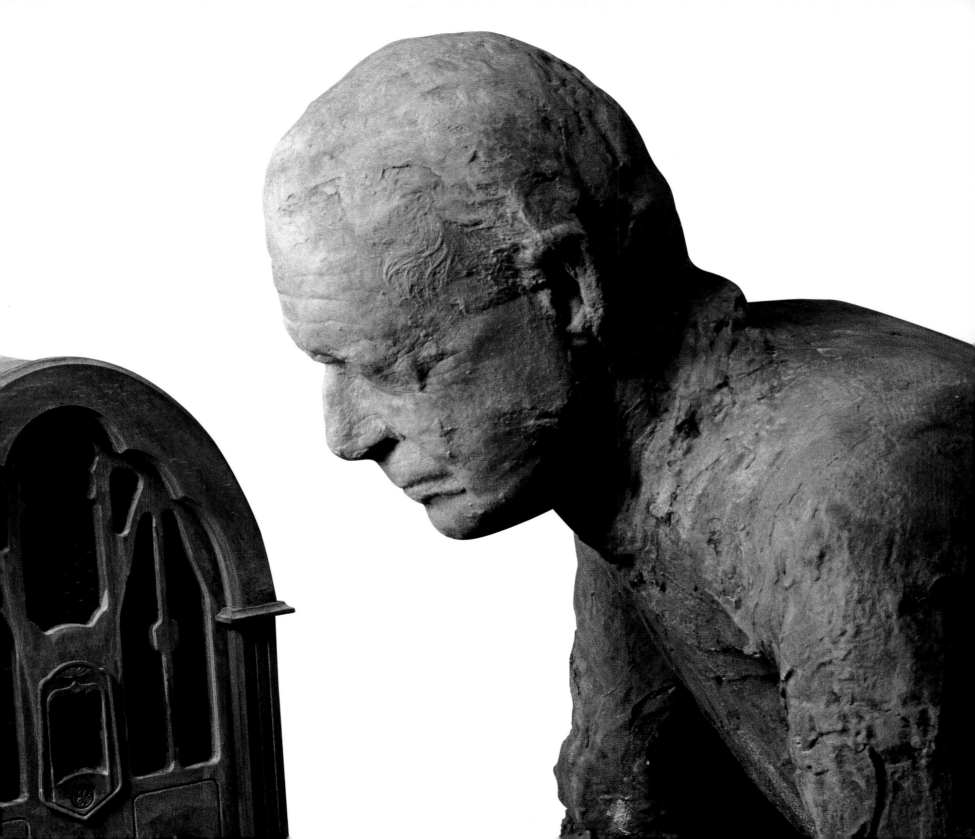

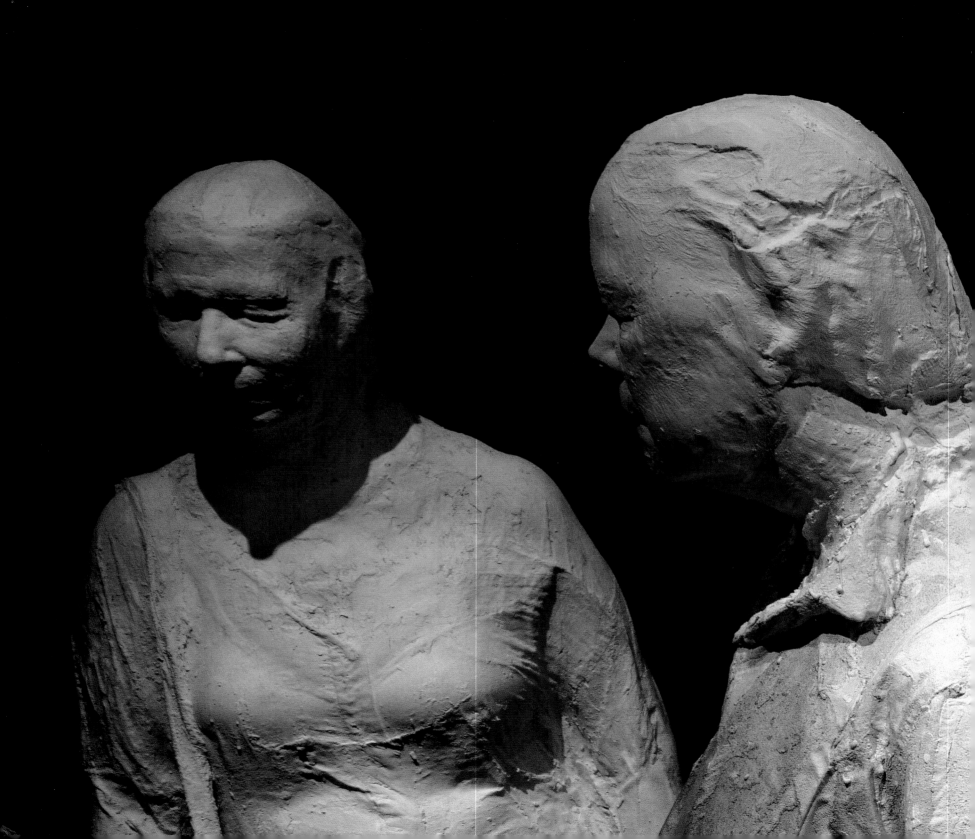

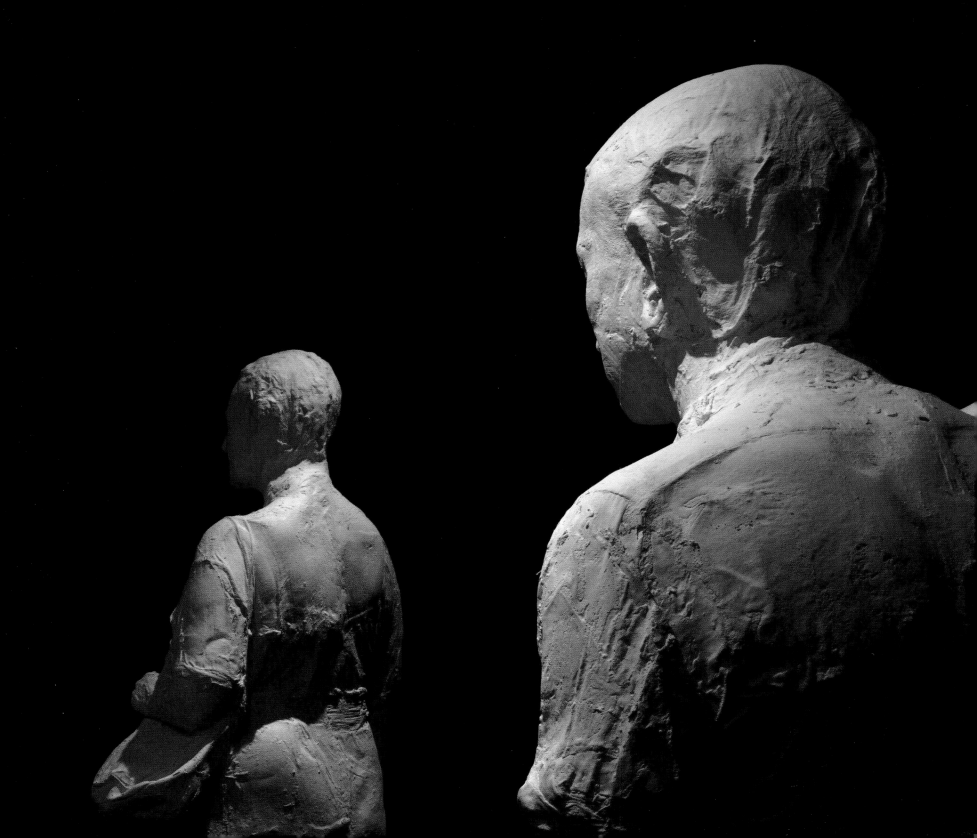

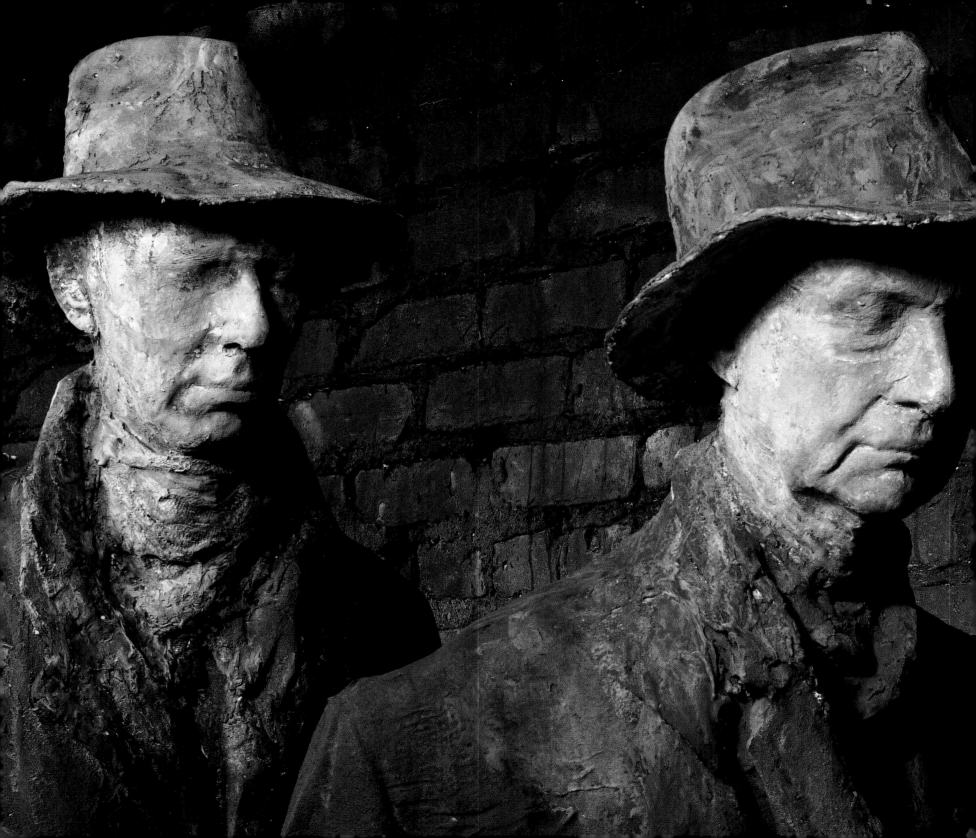

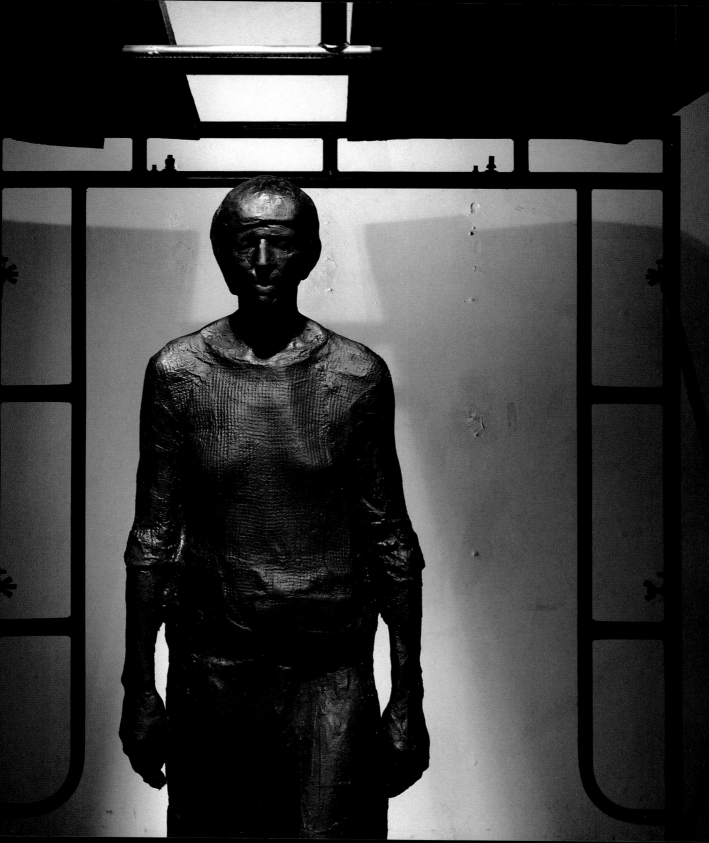

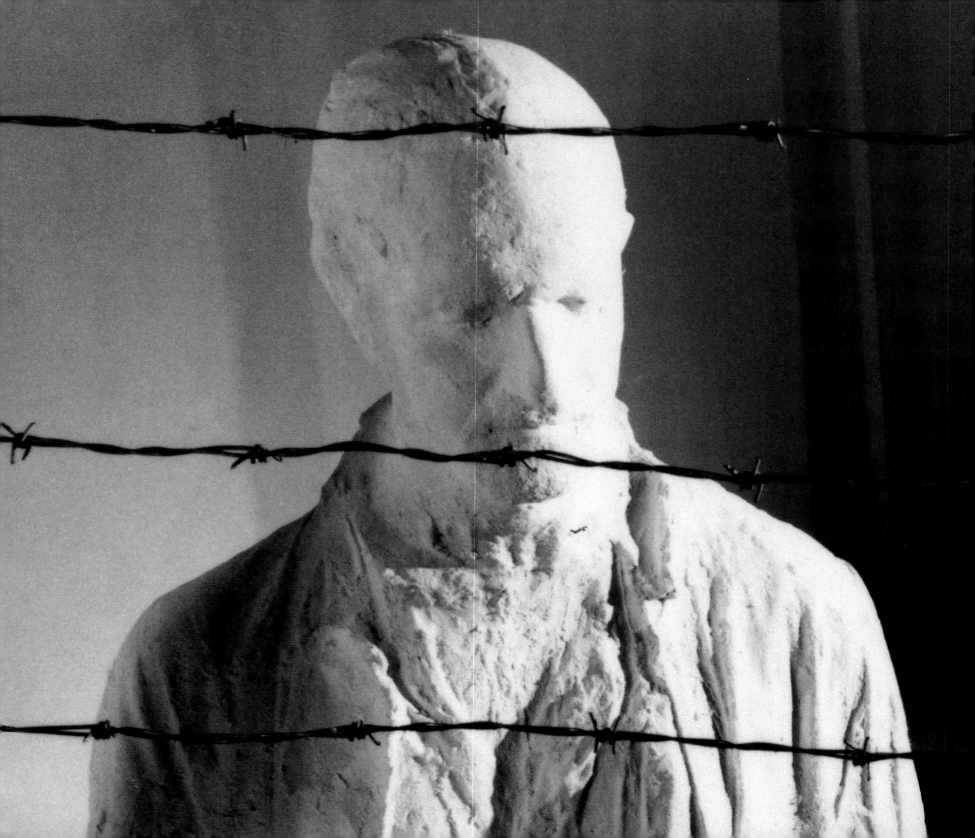

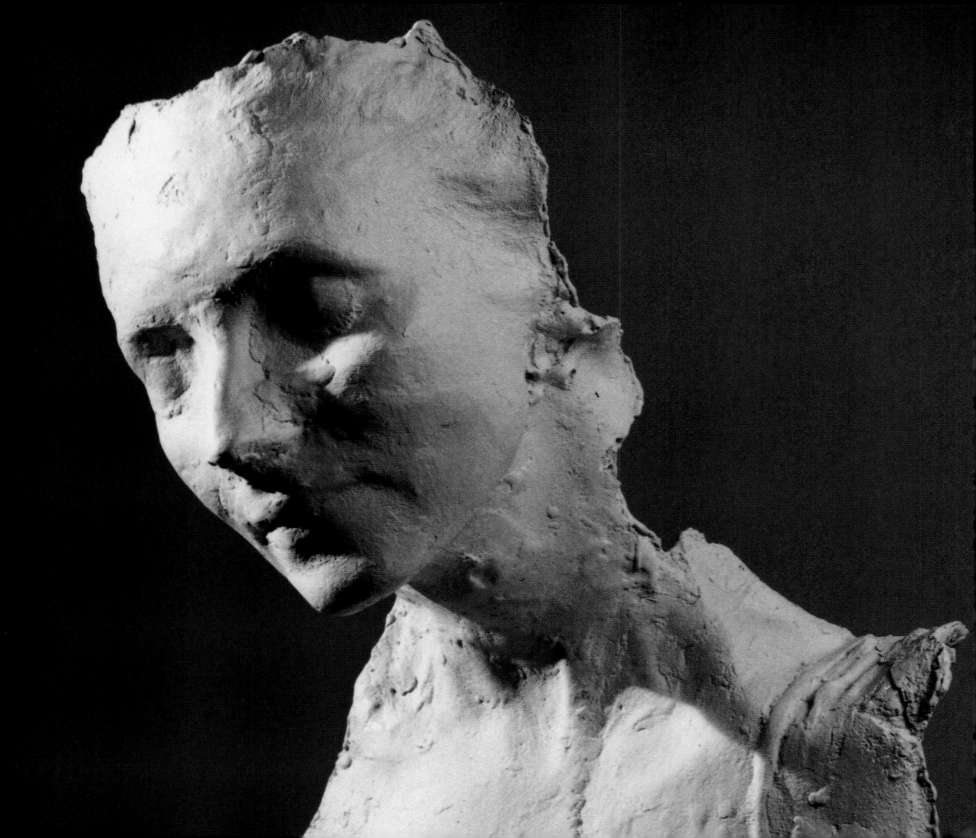

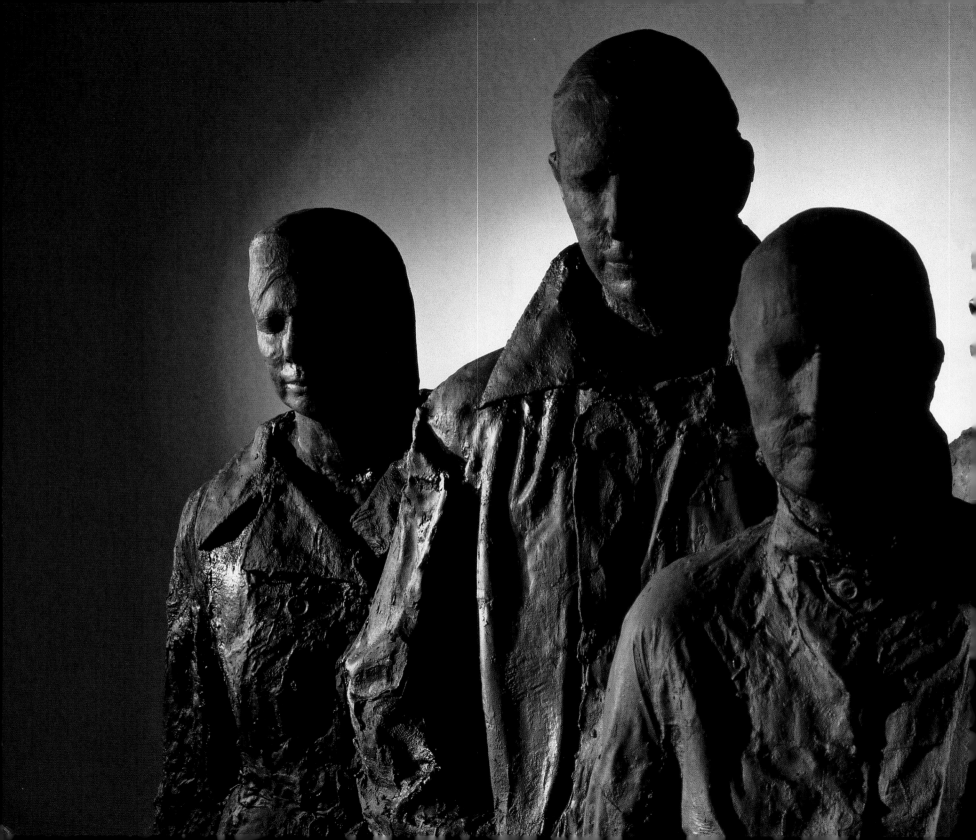

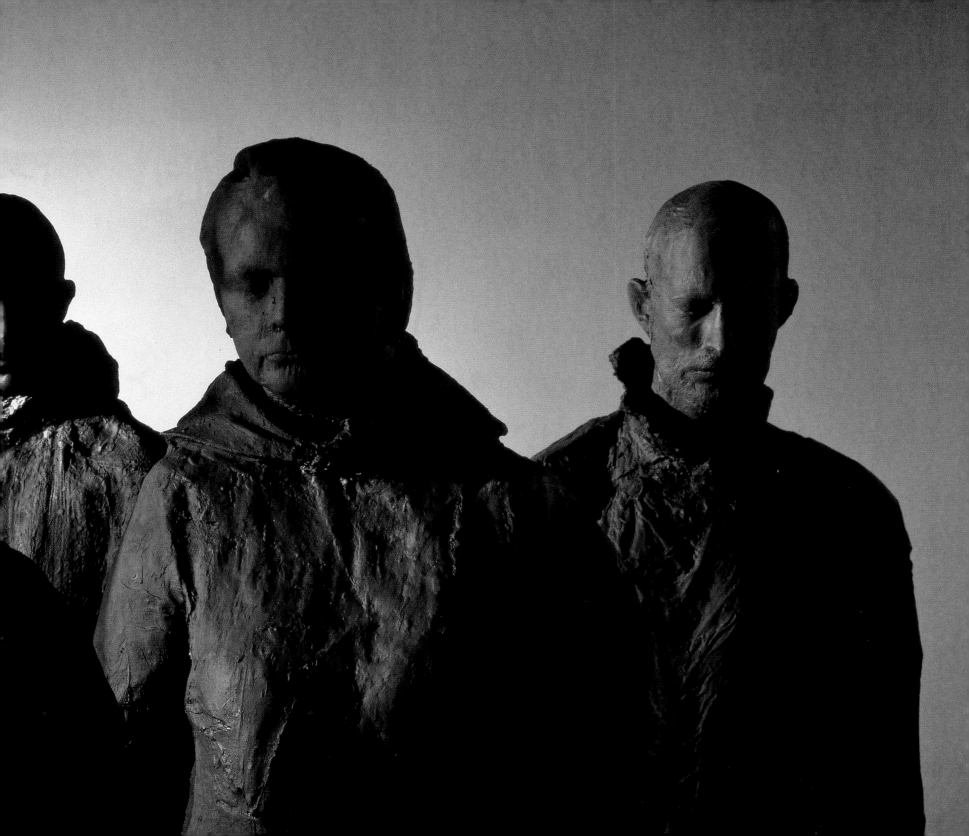

George Segal's

Bronzes

Joan Pachner

George Segal is best known for life-size white plasters created by direct body casting using plaster-impregnated gauze bandages. At once apparitional and specific, his somber, evocative environments have been a staple of the artworld since the early-1960s when he first made and exhibited them. His work is often considered in relation to Pop art, yet his psychologically empathetic images never fit the more upbeat emotional gloss of his contemporaries. Instead, Segal drew instinctively from different strains in American art and culture, looking to the scumbled surfaces of Abstract Expressionist painting, the humble realism of Edward Hopper, as well as his own gritty immediate surroundings. His sculptures in bronze, which began in 1976 and spanned more than two decades, exist on a continuum with his earlier creations.[1] Working in bronze enabled Segal to place his sculptures in outdoor settings, giving them the opportunity to interact with the world-at-large.

Plaster, historically, had not been a sculptural material of choice, the material of a finished product. But Segal loved plaster. Not only was it inexpensive, but it also satisfied his visceral need to be physically engaged with his material, like a potter with clay. He also appreciated its malleability, which he could control, and its meta-morphoses from paste to solid. Plaster also presented a white surface, like a white canvas, that because of the richly textured bandaged surface he could leave without further embellishment, or paint if he wanted to. But bronze required an additional level of process and technique and its surface had to be patinated, chemically treated, in order to preserve the metal. At first his bronze figures were confined to a traditional range of colored patinas, until 1979 when a new white patina was developed at the Johnson Atelier in New Jersey,[2] enabling him at last to successfully replicate plaster compositions in bronze, such as *Man in Toll Booth* (1979, Newark Museum, Newark, NJ, checklist no. 6). This development largely accounts for the continuity between his plaster and bronze works.

Segal was drawn into the world of large-scale bronze casting in 1976 when he was offered a commission from the Government Services Administration Art-in-Public-Places program to create a sculpture for the Federal Building Plaza in Buffalo, NY. The offer came at a propitious moment in his career when he had mastered the technique of creating complex life-casts and assembling them into tableaux and was ready for a new challenge. Cast plasters could be exhibited only in interior spaces, as the material could not withstand prolonged exposure to the natural elements. Inside, the roughly defined plaster figures contrasted starkly with the commercially produced clean lines of the architectural surroundings. Outdoors, however, in a naturally changing setting, the effect is inverted: the bronze figure is unchanging, while the environment is variable.

Segal recalled: "When I first got the commission I was laughing at…the government's insistence on eternity… Next I got lost in the beauty of those materials…"[3] The resulting tableau, *Restaurant Window* (1976, checklist no. 2),[4] introduced him to a new medium and to the other myriad aspects of creating art in public places, including official committees and engaging a larger public response than he had had the opportunity to do before. Always essentially a populist, Segal relished the opportunity to create art that would interact with more people than ever. He carefully composed a work oriented to both the passers-by as well as to the surrounding buildings. The central element is a large window, a building fragment, with three carefully placed figures, each isolated physically and emotionally, yet bound together formally by strong horizontals and verticals. For inspiration Segal looked both back in time, as well as around him, to realize a vision that would meld the ordinary with the classical: "I wanted it to look like an Egyptian rite of passage… but look ordinary like an American restaurant."[5] Whereas the relative stiffness of the figures may have been purposeful, it also may have been the result of his learning curve with the material, as he tried to figure out how to

retain the vitality of the original plasters in the new medium. The urge to express a contemporary subject in classical terms is restated often in his oeuvre, most obviously perhaps in *Woman Walking Under Scaffold* (1989, checklist no. 29), where the central figure emulates the stance of Egyptian statuary.

Restaurant Window depicts strangers co-existing in public places, much like the people who pass the sculpture every day. As he had done earlier, in plaster, with *The Diner* (1964-66), Segal seems to have composed the work to intentionally maximize the separateness of the figures and their lack of interaction. This distinctly urban sensibility is restated in many of his subsequent tableaux, including *The Commuters* (1980, Port Authority Bus Terminal, New York City, checklist no. 8), *Rush Hour* (1983, checklist no. 16), the historically evocative *Depression Breadline* (1991, Franklin Delano Roosevelt Memorial, Washington DC, checklist no. 31) and *Street Crossing* (1992, checklist no. 33).

The most ambitious expression of alienated urban existence is *Street Crossing*. This life-size, multiaxial, seven-figure composition is clearly indebted to Alberto Giacometti's existential tableau *City Square* (1948), but also evokes the fundamental importance to Segal

George Segal, *The Diner*, 1964-66

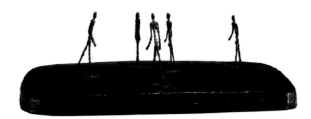

Alberto Giacometti, *City Square*, 1948

of Jackson Pollock's "limitless universes."[6] Segal choreographed the casually dressed, mute, white figures like chess players in such a way that their trajectories would cross but the figures would never touch. The interplay between negative space and ironically white bronze figures is palpable as the ghostly subjects seem condemned to wander in dream-like eternity evoking a stratum of Dante's *Inferno*. Open at its center, *Street Crossing* seems to have exploded and scattered the mass of commuters in the darkly patinated *Rush Hour*. This is a richly conceived, important environmental tableau that establishes a dialogue with both the history of art and with Segal's own work.

The Dancers (1982, checklist no. 13) is commonly discussed in terms of its art historical precedents in Matisse and Degas, yet the composition differs significantly from these models in its earthiness. There are no props to augment the life-size figures, which are endowed with ample thighs, breast and buttocks; their movements seem constrained by gravity. These women are not wraith-like, as professional dancers often are, and in fact, only one of them was. The circular composition does not have the feeling of speed, but instead of slow motion, perhaps of learning, practicing, trying to coordinate movements that are not yet synchronized. Each figure seems intent on his or her pose, straining to stay aloft. This inherent awkwardness enhances the sculpture's appeal, making it approachable on an emotional level to the experience of most passers-by who can identify with the effort, even mimic the poses. While many of Segal's bronzes are highly detailed, *The Dancers* is an exception, for its relatively simplified surfaces typify his earlier creations. In fact, this work was made in plaster more than ten years before it was cast in bronze. It is one of the first examples of his newfound ability to successfully emulate his original material.

In addition to the large, multi-figure bronze compositions, Segal continued to set his characters into meticulously calibrated spare settings: "The figure is only one of the things that punctuates the space. I work for a long time and eventually there is nothing I can subtract; whatever is left there has to be there."[7] *Girl Standing in Nature* (1976, checklist no. 3), created immediately after *Restaurant Window*, is among his most spare and resonant outdoor bronze installations. This solitary, tender young woman seems to represent an emotional retreat to the forest, to a mood of tentativeness, but it also represents a reaction on behalf of the artist against the development of large-scale geometric abstractions, a path he had purposefully rejected in favor of life-size figuration. *Girl Standing in Nature* also marks an early stage of his work with bronze, a point at which he has gained increasing mastery over the forms (including the casting of a large rock taken from a real rock he had seen during his travels near Jerusalem) but not yet over the patina, which is a traditional, albeit appropriate, weathered green.

Gradually he came to use a wide range of patinas, even varying surface color within editions. For instance, *Man on a Bench* (1985, checklist no. 21), which depicts an African-American male in casual clothes seated with his fist clenched on his lap, legs relaxed open, on a real metal park bench, was created with both a dark patina and a light one. Segal, who was deeply sensitive to political and racial issues in American culture, used the different colorations knowing that they would provoke different reactions from the viewing public, adding layers of emotional complexity to the sculpture. In other instances, he took torch and chemicals into his own hands, and created new, painterly patinas directly on some of the bronzes, reclaiming control of the process.

A group of solitary figures mediated through the device of the window or other scrim in poses that immediately call to mind the paintings of Edward Hopper were made in a cluster around 1980, including *Man in Toll*

Booth (1979), *Girl in Kimono Looking Through a Window* (1980, checklist no. 10) and *Man Looking Through Window* (1980, checklist no. 11). As with *Restaurant Window*, we simultaneously see both sides of the action, like a movie set. The window provides both protection for a vulnerable subject and a way for the viewer to peer in, intruding on the privacy of an unknown person. We unwittingly become voyeurs.

Segal placed some other models on park benches and in chairs. The white *Woman with Sunglasses on Bench* (1983, checklist no. 17) sits in the middle of a metal bench, her central placement echoed by her torso's naturally symmetrical division, revealed clearly beneath her sheer summer dress. Segal transformed a casual pose into a contemporary icon. Most of his female bronze subjects, however, lounge in chairs, such as *Woman in Armchair* (1994, checklist no. 34), evoking nineteenth century prototypes of women daydreaming, reading or otherwise internally engaged in private reverie. The frankly erotic *Fragment: Venus Gesture* (1986, checklist no. 23), which may be an homage to Gustav Courbet's *L'Origine du Monde* (1866), can also be considered in this company.

While Segal's oeuvre is often characterized in terms of his scenes of contemporary isolation and alienation, the true range of his work is broader than most realize. For instance, *Gay Liberation* (1980, Sheridan Square, New York City, checklist no. 9) depicts tender interaction and, like *Three People on Four Benches* (1979, checklist no. 7), is literally open to public participation. Interacting figures populate tableaux regarding workplace situations, including *The Steelmakers* (1980, Youngstown Area Arts Council, Youngstown, OH, checklist no. 12) and *Circus Acrobats* (1988, checklist no. 25). Other arrangements, such as the *Couple on Two Benches* (1985, checklist no. 20), concern the awkwardness of private interaction in public space. There is space for seating, but who would want to disturb the intimate conversation?

The darkly patinated *Chance Meeting* (1989, checklist no. 27) feels like a scene from an unknown film noir of the 1950s, perhaps a gathering of conspirators. The mysterious but evocative group invites speculation about who they are, why they are there and what they are doing, engaging the viewer once again as voyeur. "The all black thing had to do with light... If I have an all black piece, and I set up the light right, I can set up an incredible range of grays, just by placing a light."[8] This three-figure composition, which includes crossed "one way" signs, draws on the earlier frontal plaster *Walk, Don't Walk* (1976), which depicts people waiting on a street corner for the sign to change. The sign itself is a prominent aspect of the work, which is dominated by hauntingly blank frontal stares. It also looks to the more confrontational nature of the trio in *Street Meeting* (1977), a darkly painted plaster and wood piece. The clothing in *Street Meeting*, however, is more casual and the drama suggested by the two women looking intently at the man with crossed arms is provocative and more domestic in nature. Is it a father with two daughters, a daughter and a wife, or a man with two lovers? Relationships in this pyramidal composition are drawn with invisible site lines, emotions communicated with spare gestures. Ambiguity

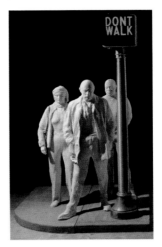

George Segal, *Walk, Don't Walk*
1976

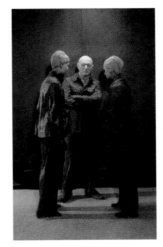

George Segal, *Street Meeting*
1977

lays at the heart of these environmental tableaux, as it does in all of Segal's work, for he intentionally created open-ended situations, presenting questions, rather than answers. His masterful use of ambiguity forged a unique and unexpected link between the languages of naturalism and abstraction.

Bronze, a medium central to the history of sculpture, was rejected at mid-century because of its associations with the crushing weight of tradition that the avant-garde was poised to reject. This rejection had to pass through several generations before the medium could be reclaimed for modernism. Segal liked to experiment with the placement of cast arms in various positions, to play with the casting process, bending it to his will, to his own style and working method. As always, his knowledge of the past informed his work but did not stultify it.

From the vantagepoint of 2003, George Segal's figural creations seem to be harbingers of a new generation who emerged by the later-1980s, a model for how to approach a tradition-laden subject within the context of modernism. Segal's early sculptures were formed against the backdrop of Happenings and Pop art. His development remains most closely allied with Claes Oldenburg, although clearly the trajectory of their work diverged. Segal's work also differs considerably from Edward Kienholz's surrealist tableaux, and from the heightened realism of John de Andrea and Duane Hanson, both of whom also made casts from live models, as well as the current hyperrealism of Ron Mueck and Charles Ray. But today we see that Segal's oeuvre opened

the way for the psychological figures of Kiki Smith, and perhaps to the contemporary archaism of Antony Gormley, or the lesser-known works of Jonathan Silver.

Few of Segal's bronzes are memorials, yet they all honor their subject. While he used bronze's innate capability for faithful reproduction of detail, his aim was never to amaze an audience with his meticulous rendering of a particular person, but rather to use the specific to evoke a spectrum of mood and universal concerns. His sculptures of everyday life using regular people surrounded by real objects, set at ground level, have literally engaged the public with modern art in a way that few have been able to do. The bronzes enabled Segal to make the transition from the art world to the real world, where his subjects live and his work belongs.

1. Segal did make one bronze much earlier in his career, a portrait commission in 1963 for the collector Robert Scull, checklist no. 1.
2. This date has been confirmed with the Johnson Atelier.
3. Phyllis Tuchman, *George Segal* (New York: Abbeville Press, 1983), p. 98.
4. According to The George and Helen Segal Foundation, Segal titled the plaster *The Restaurant* but called the bronze tableau *Restaurant Window.*
5. Tuchman ibid.
6. See George Segal interview with Barbaralee Diamonstein, *Inside York's Art World* (New York: Rizzoli, 1979), p. 359.
7. Ibid., p. 360.
8. See transcript of the PBS documentary by Amber Edwards, *George Segal: An American Still Life,* "The Artistic Process and Casting from Life," p. 6 of 7.

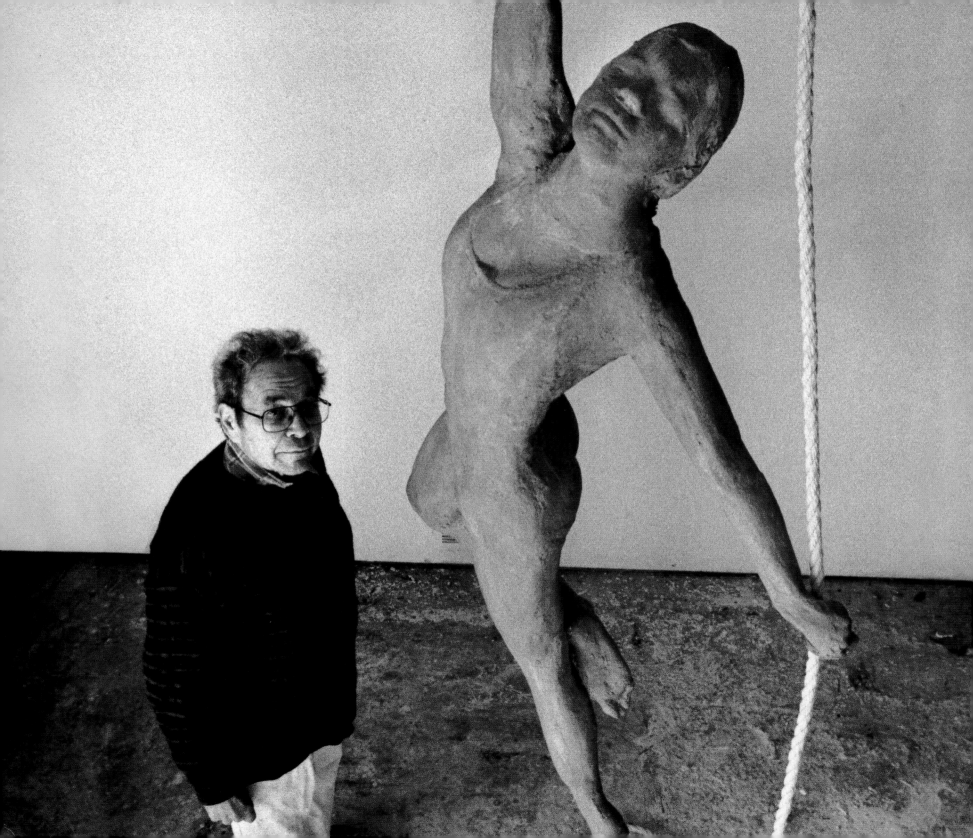

Plates

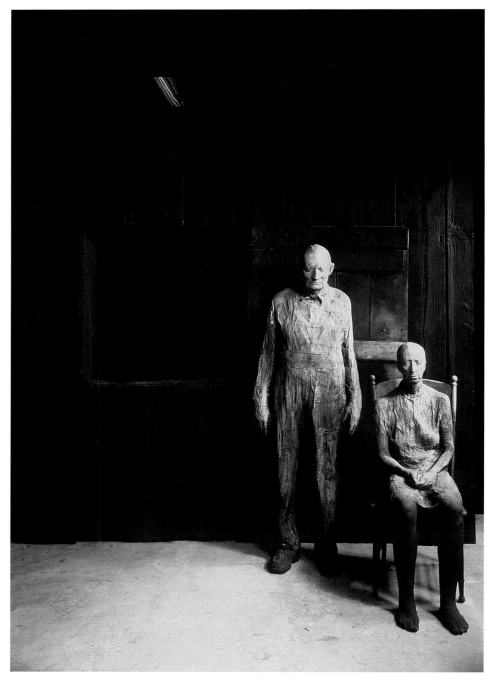

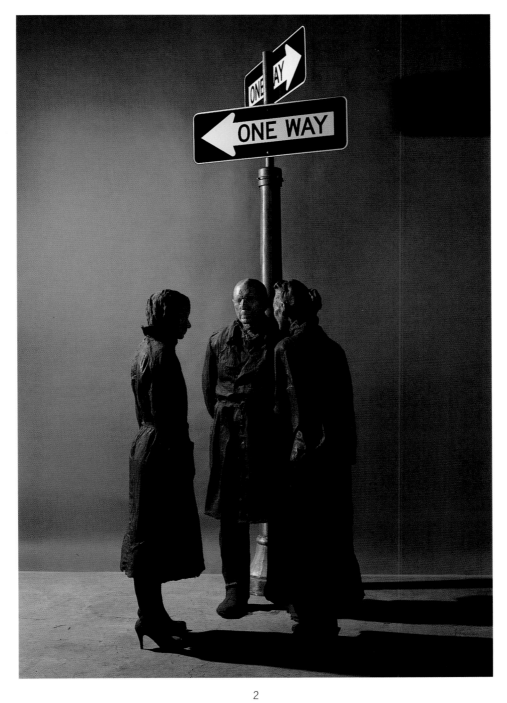

2

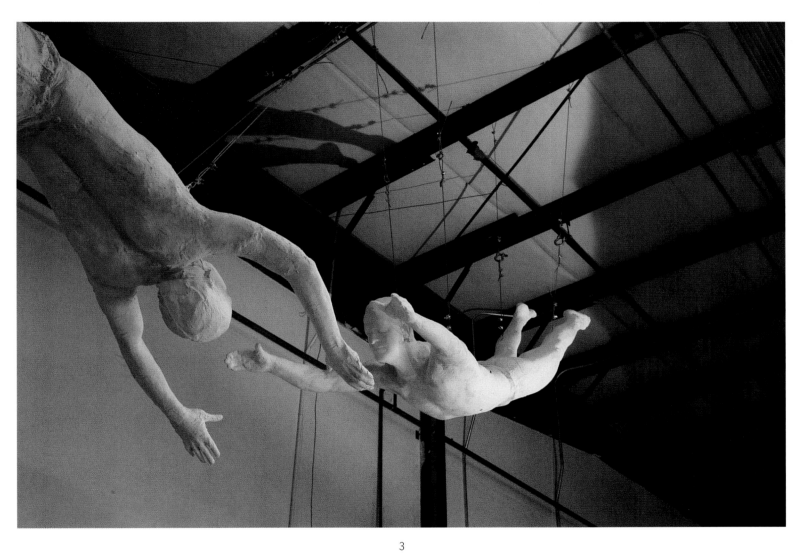

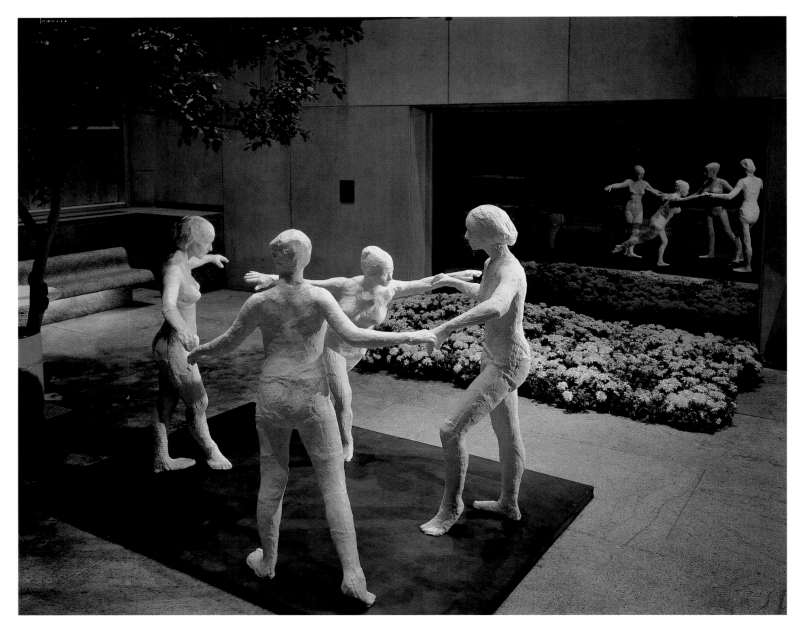

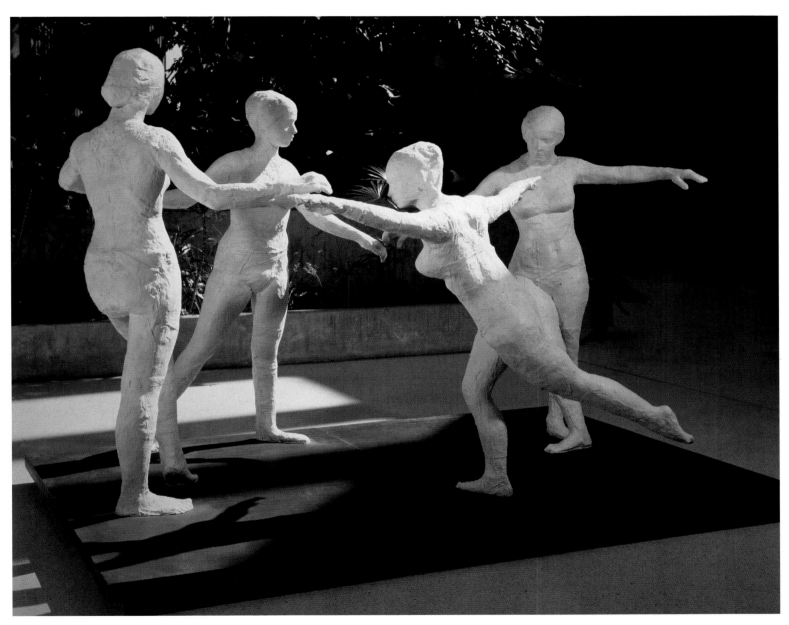

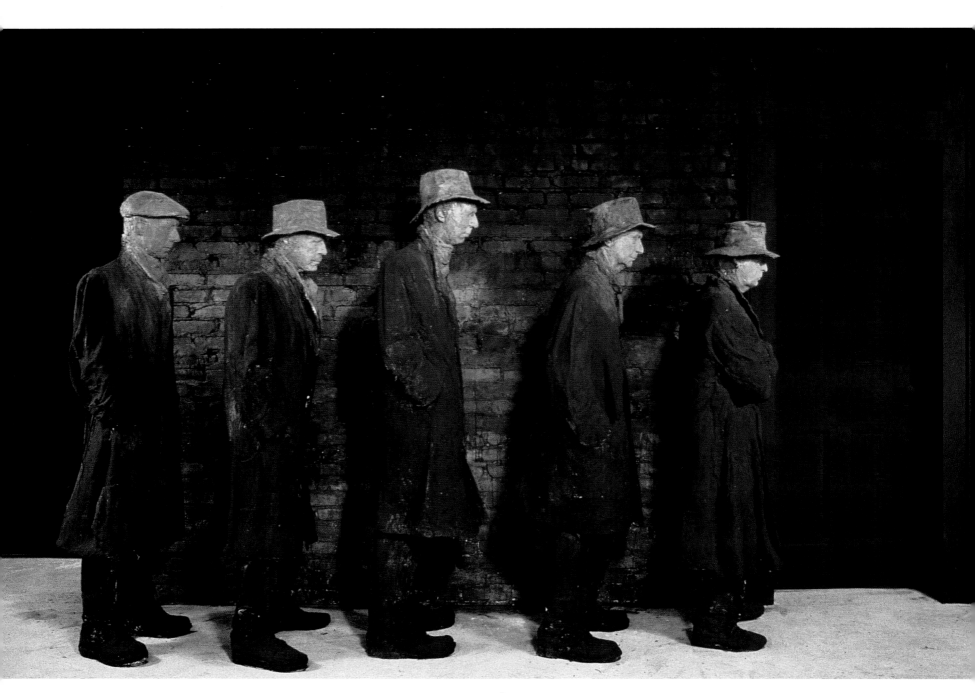

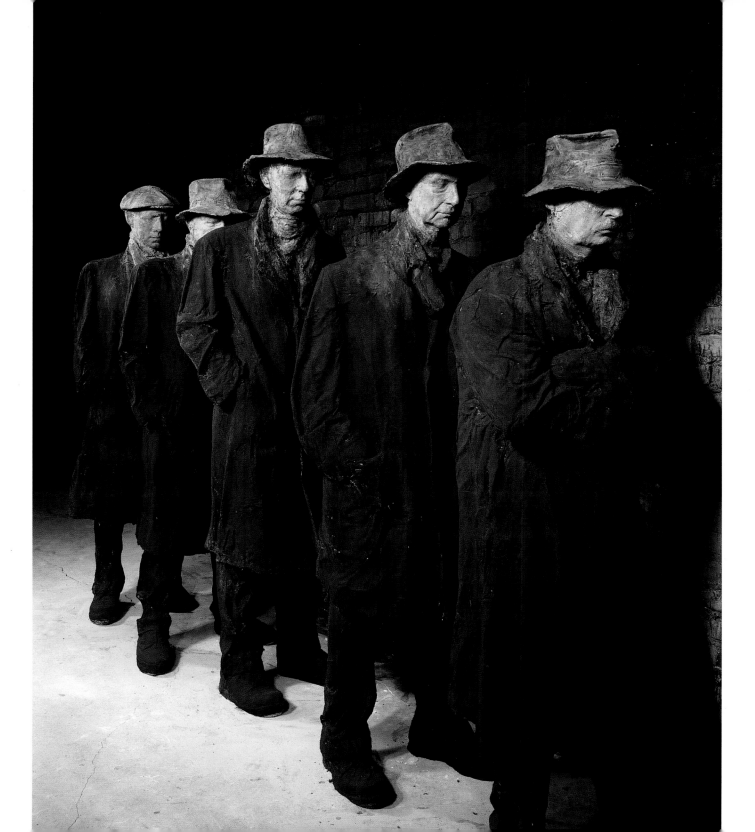

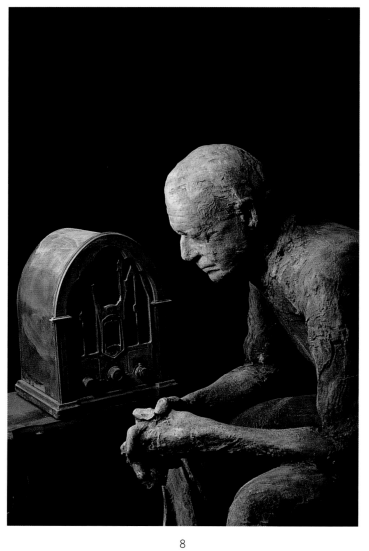

8

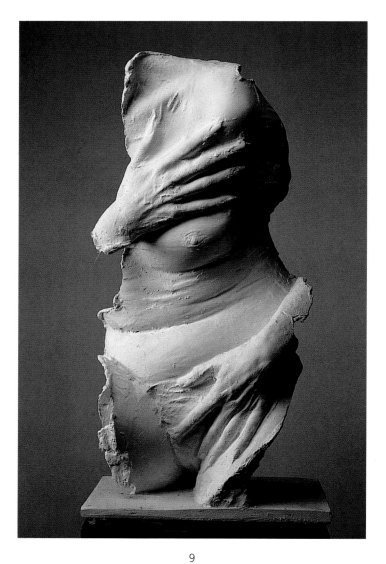

9

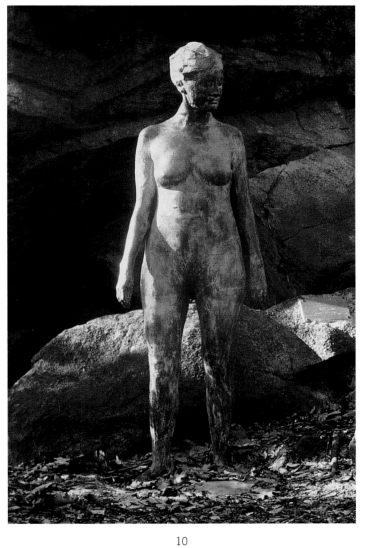

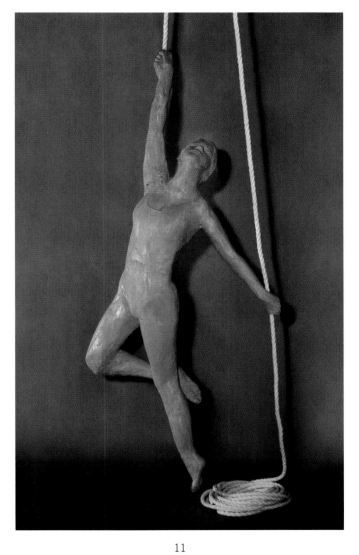

10

11

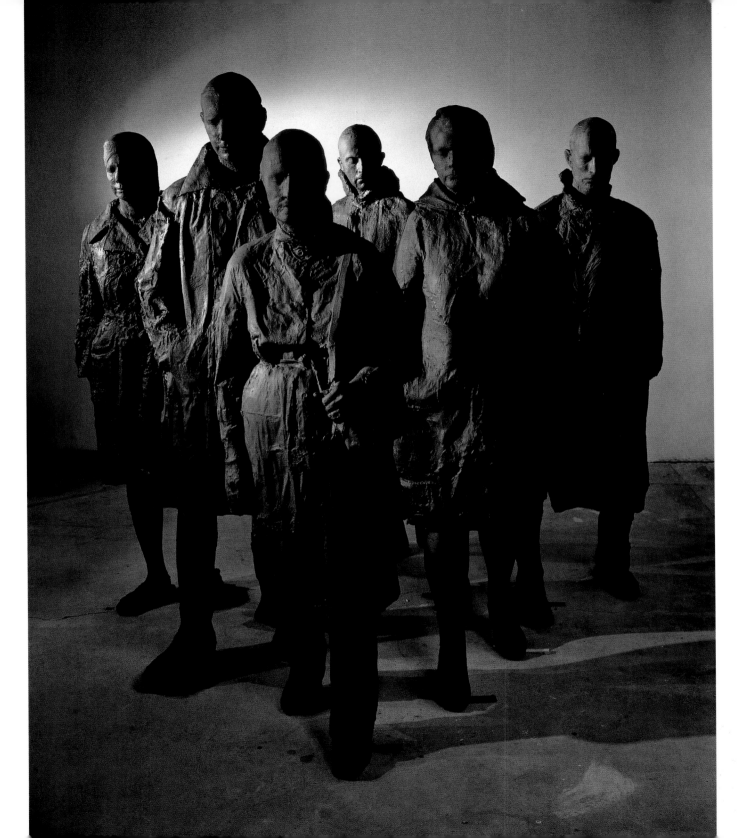

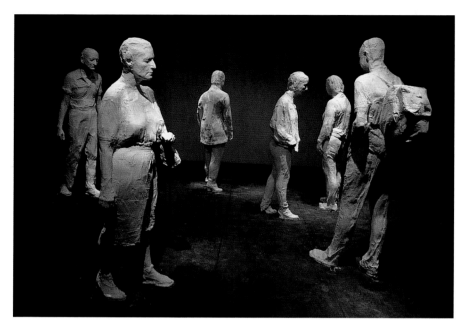

13

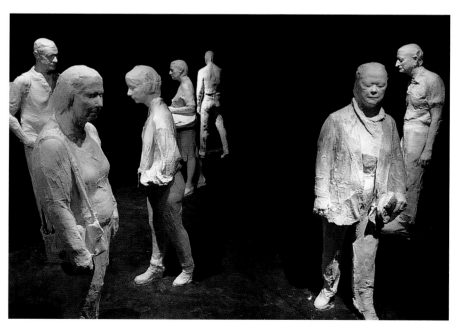

14

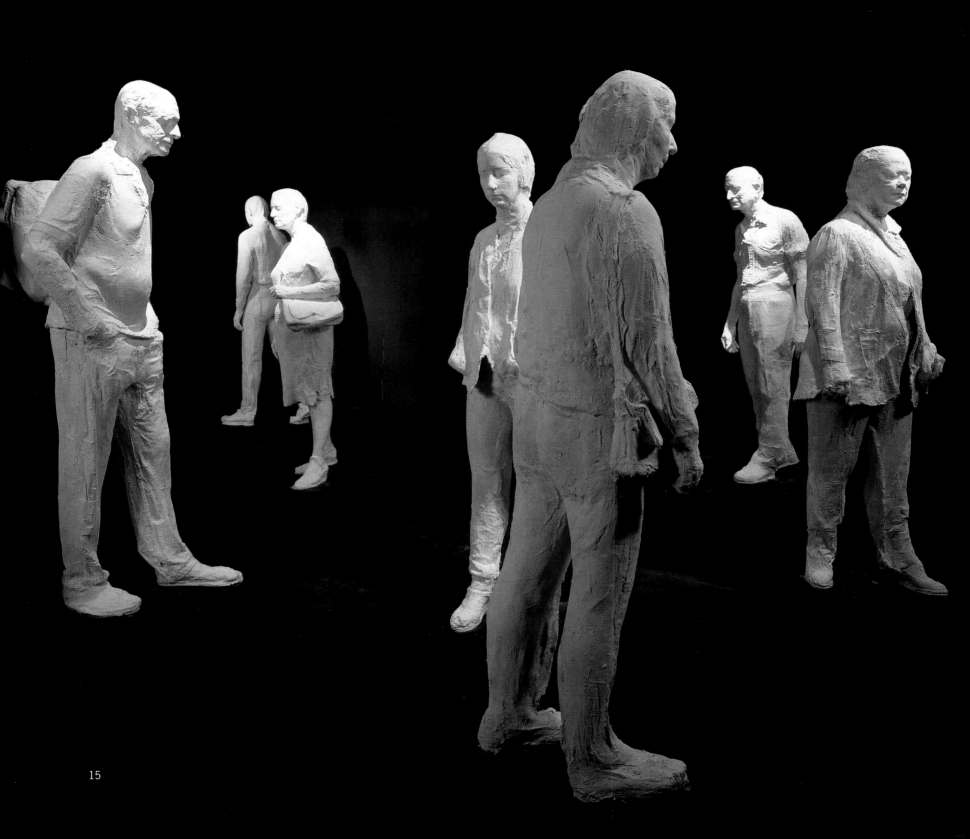

15

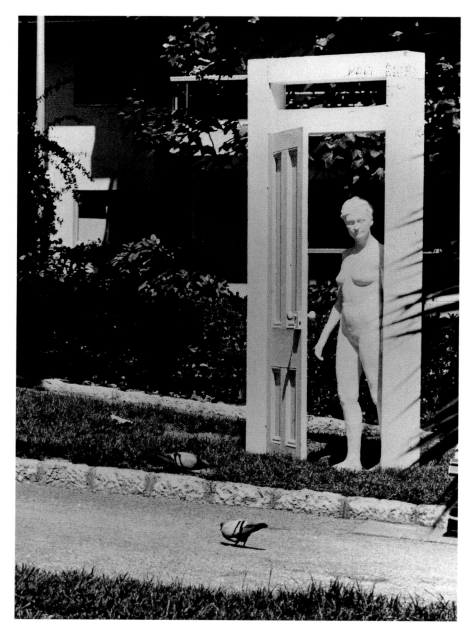

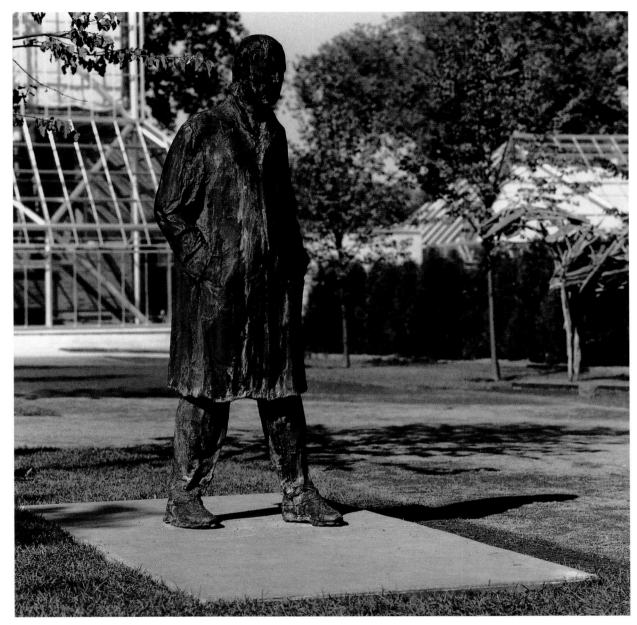

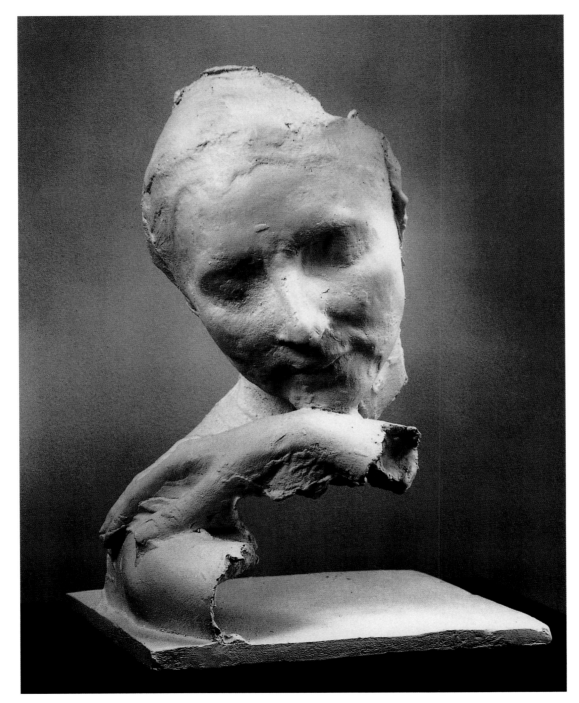

18

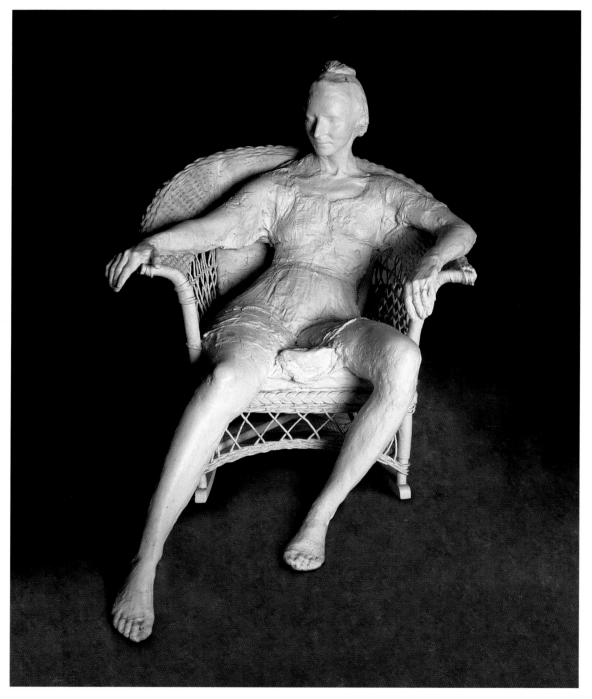

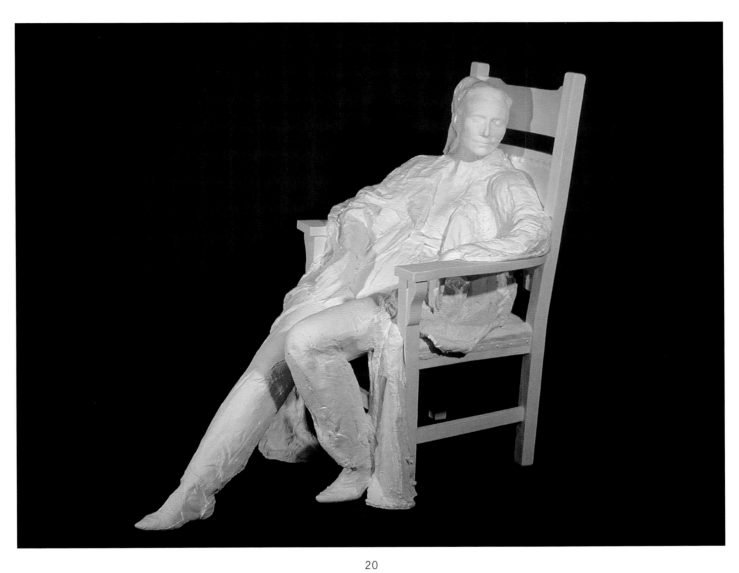

20

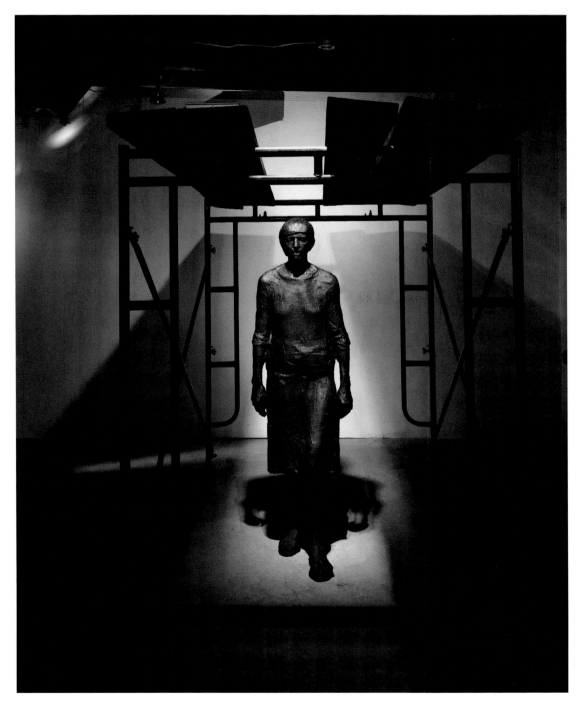

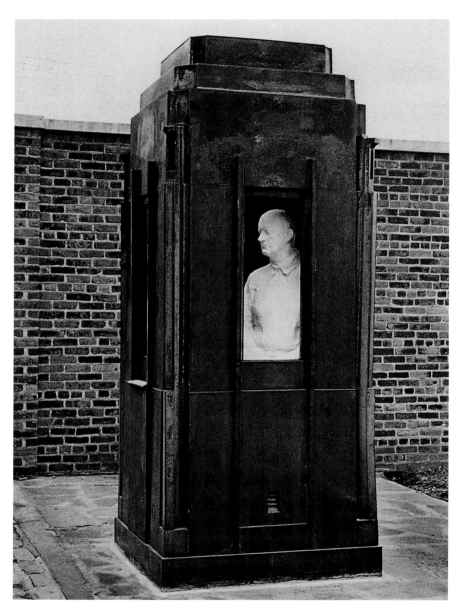

22

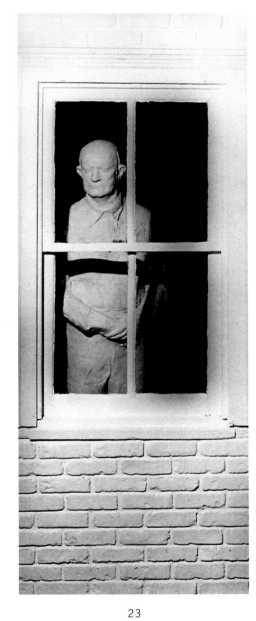

23

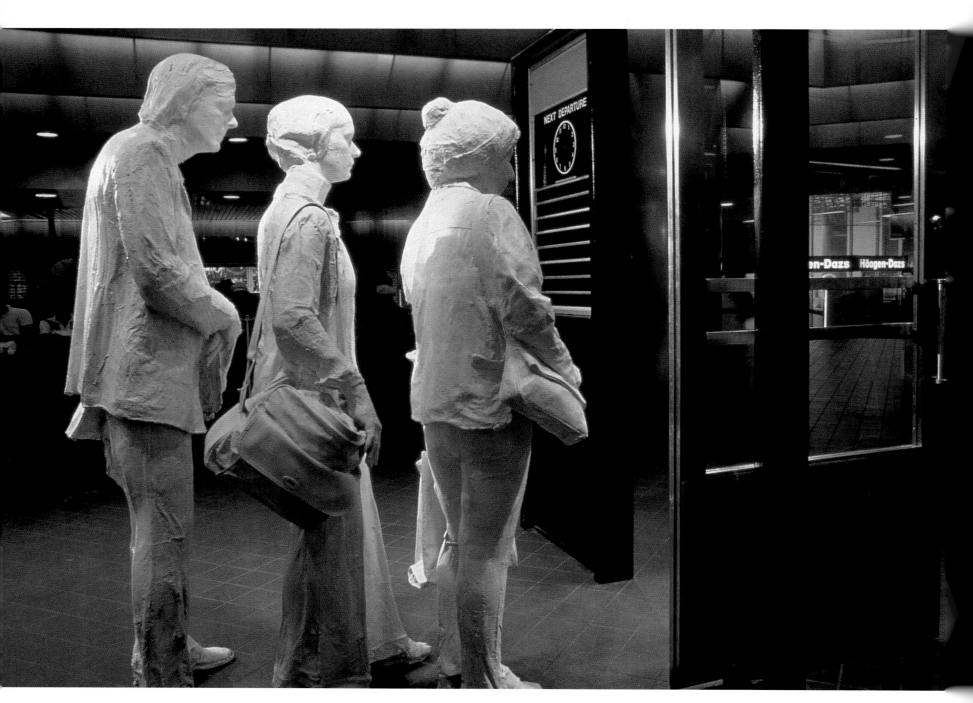

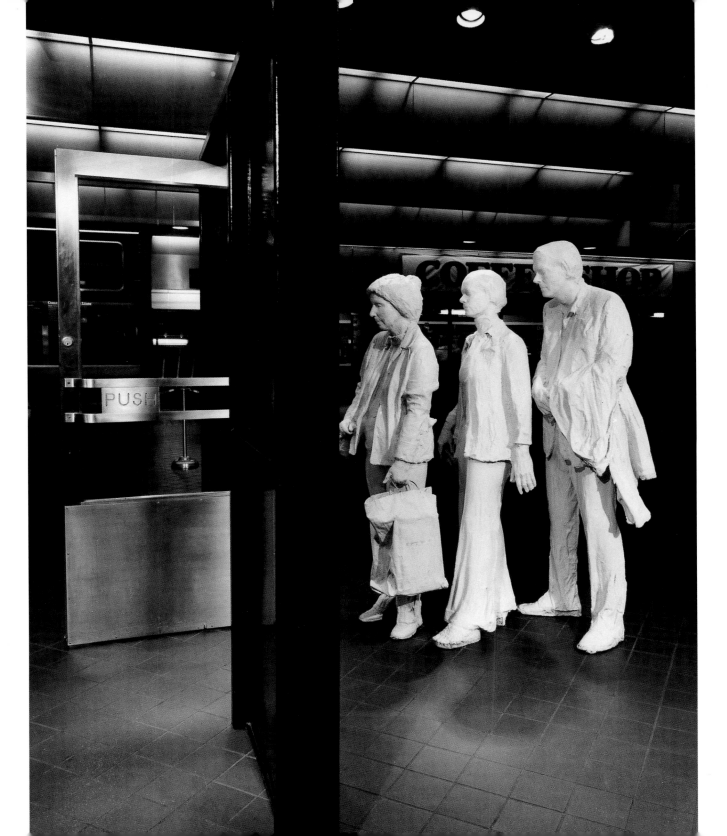

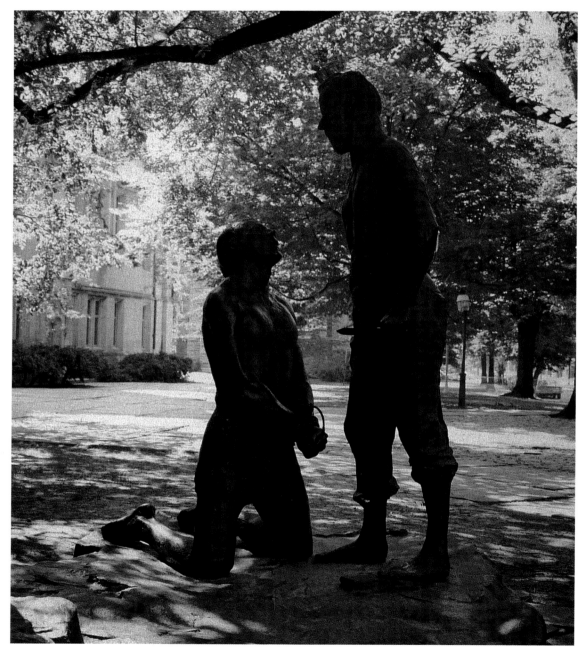

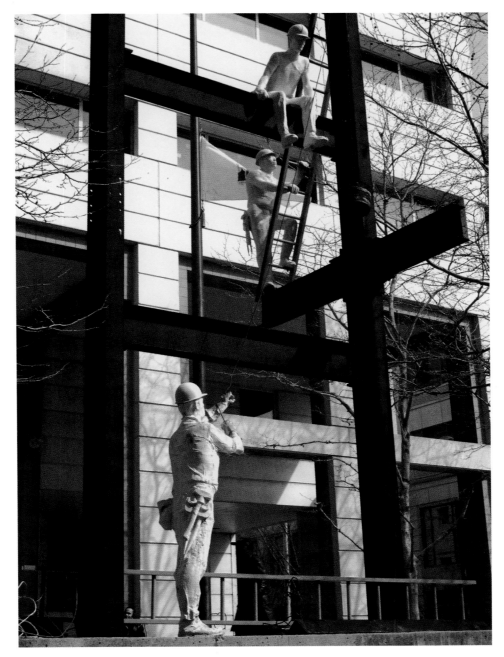

27

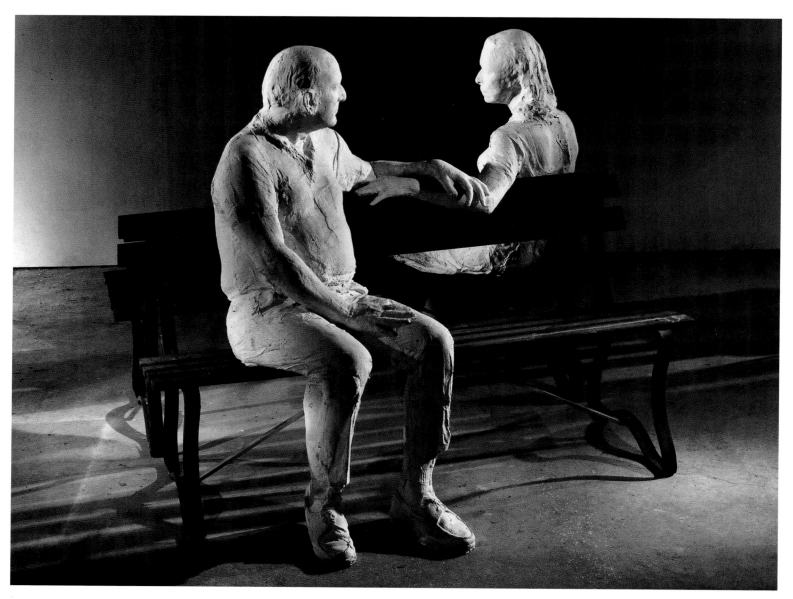

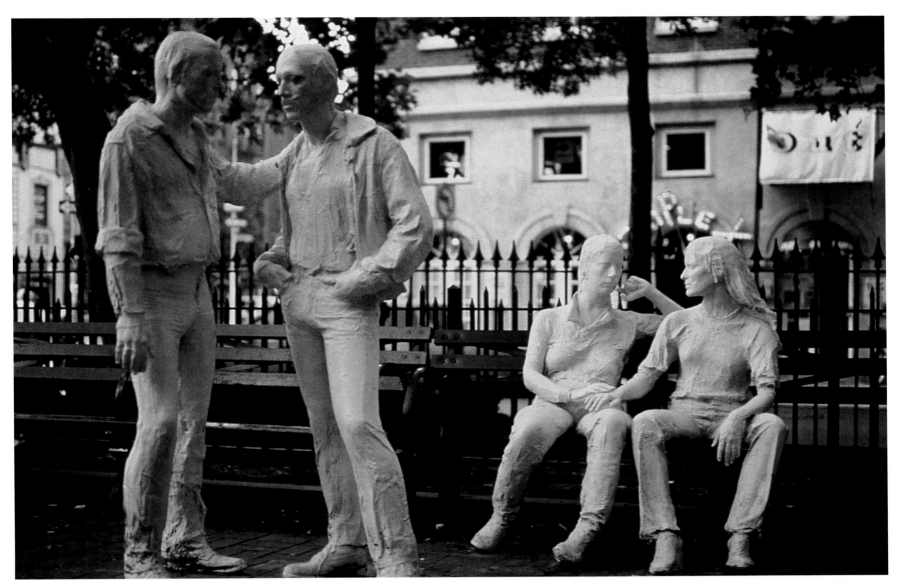

29

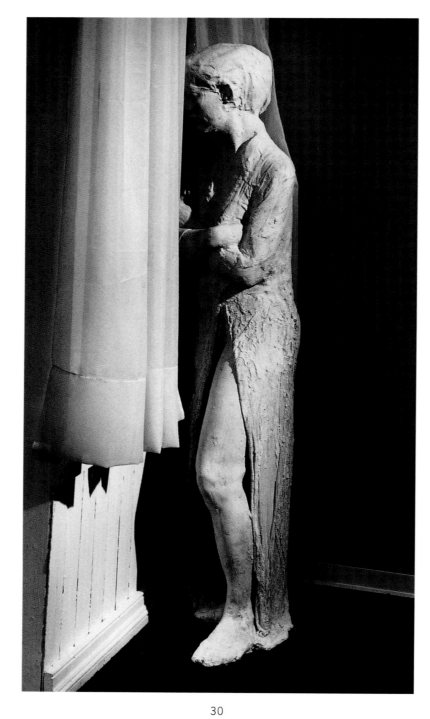

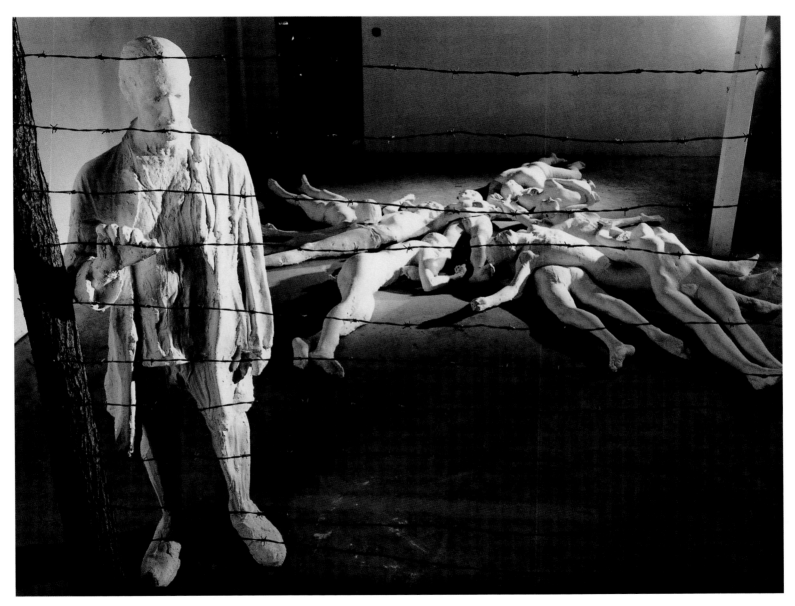

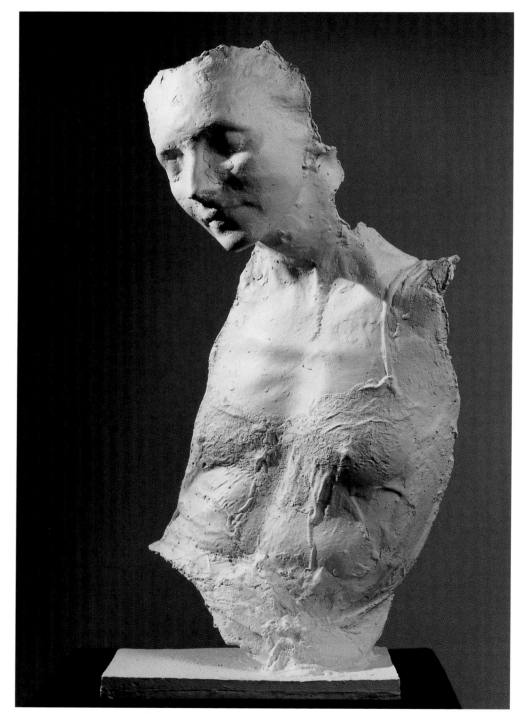

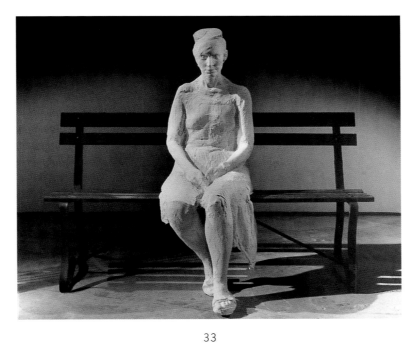

33

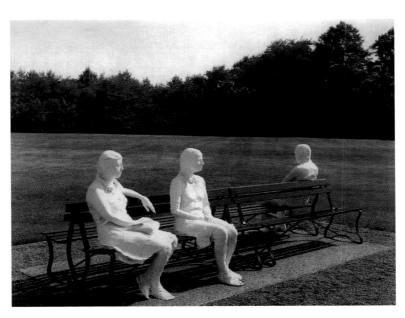

34

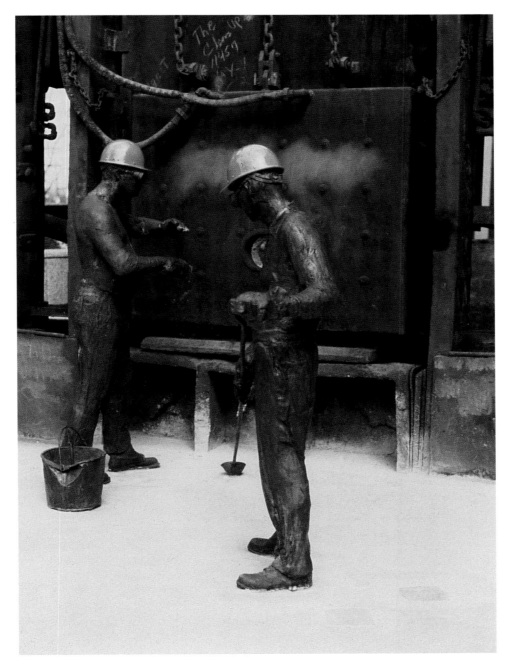

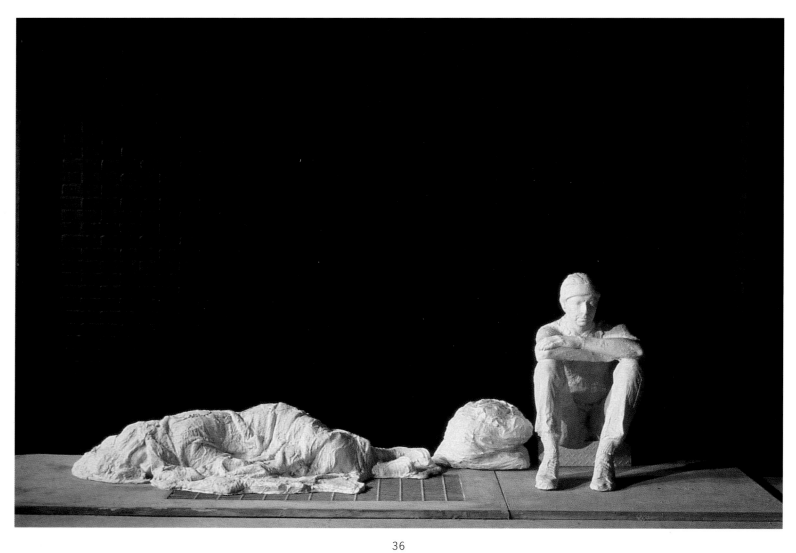

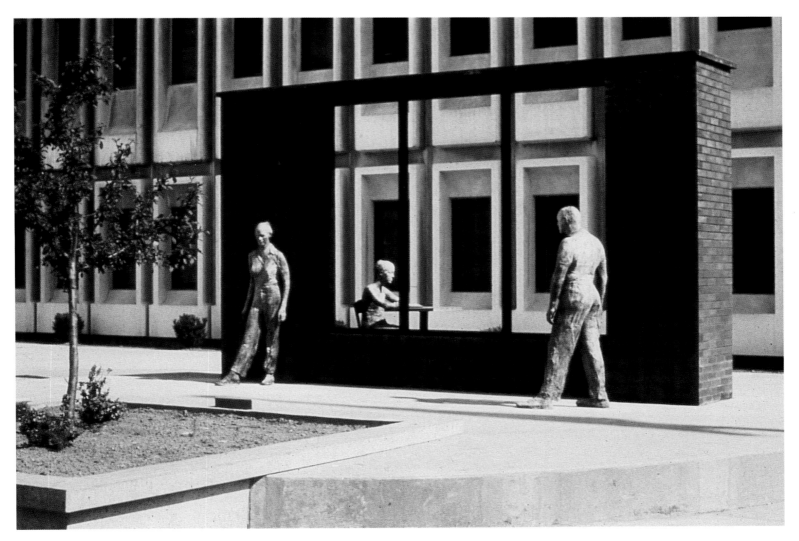

37

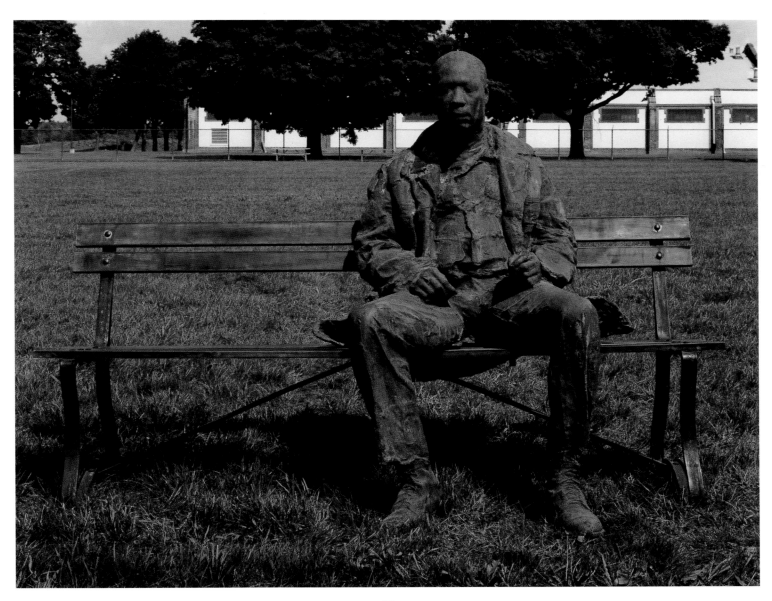

38

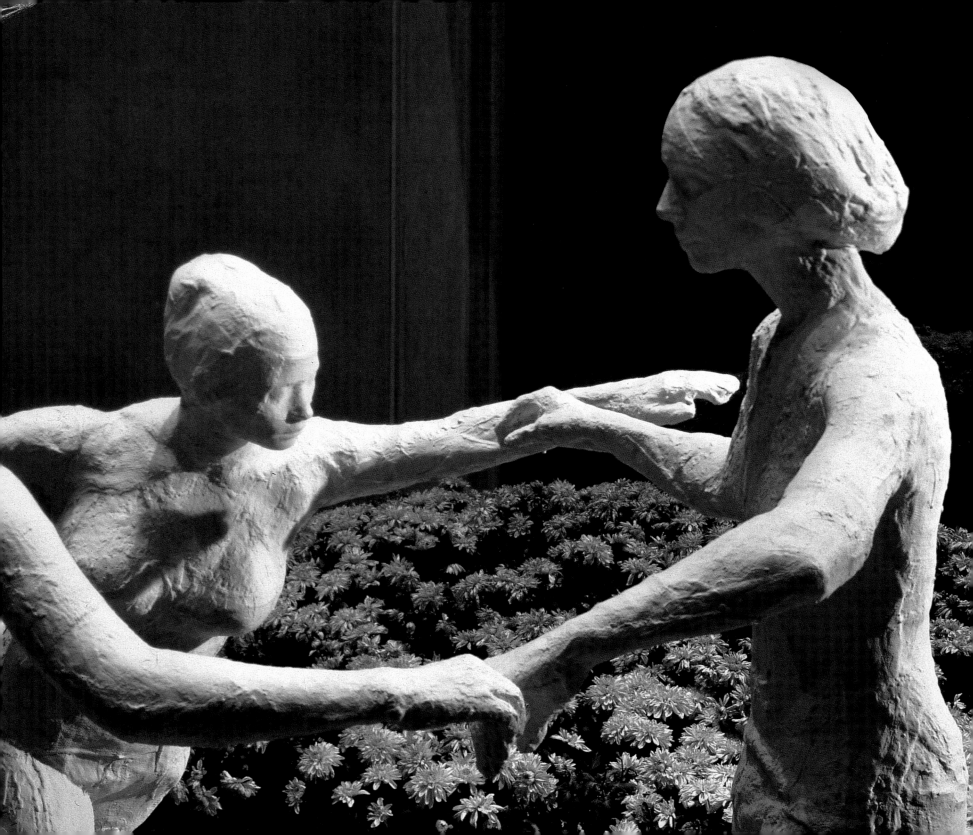

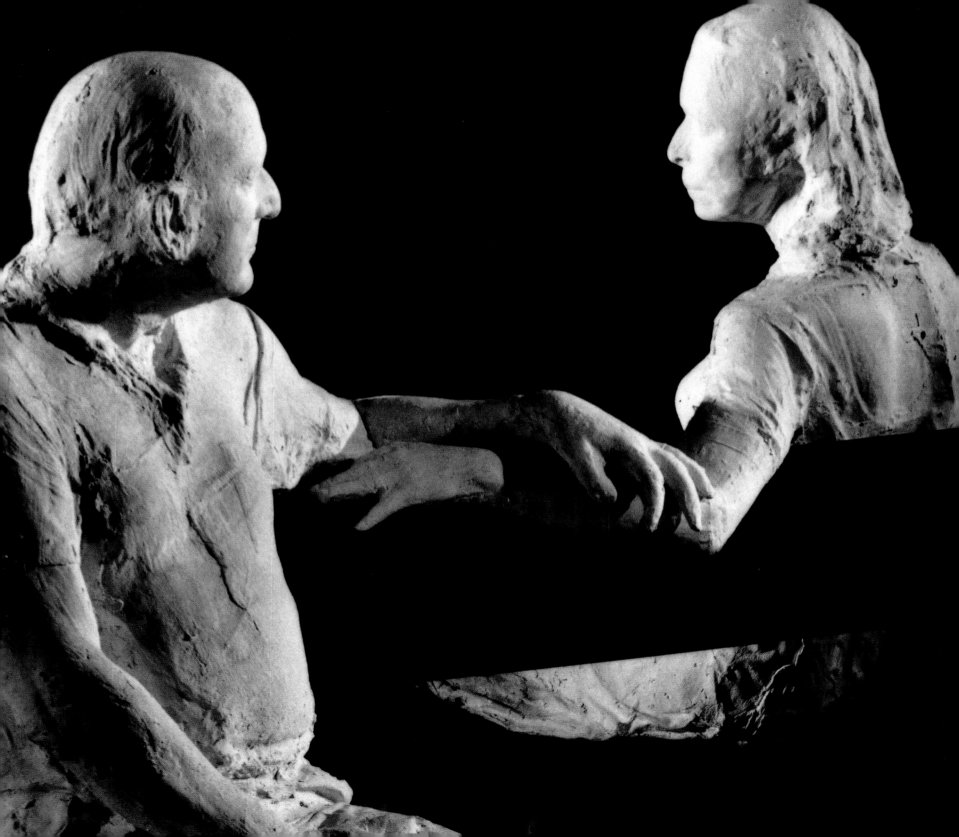

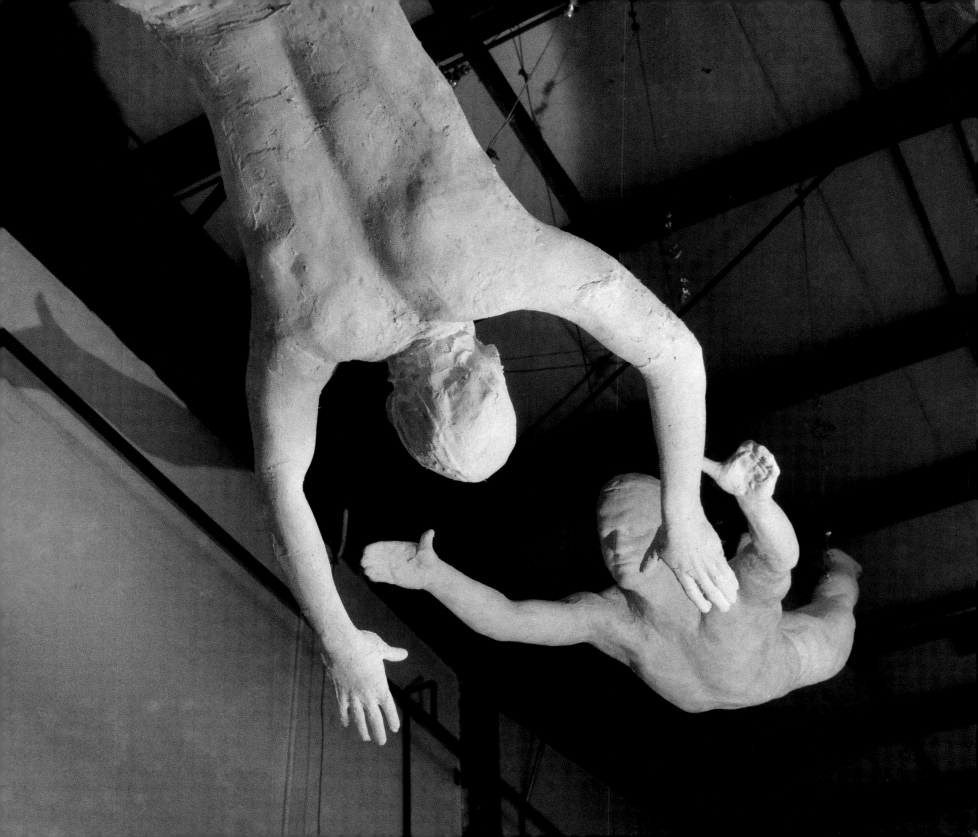

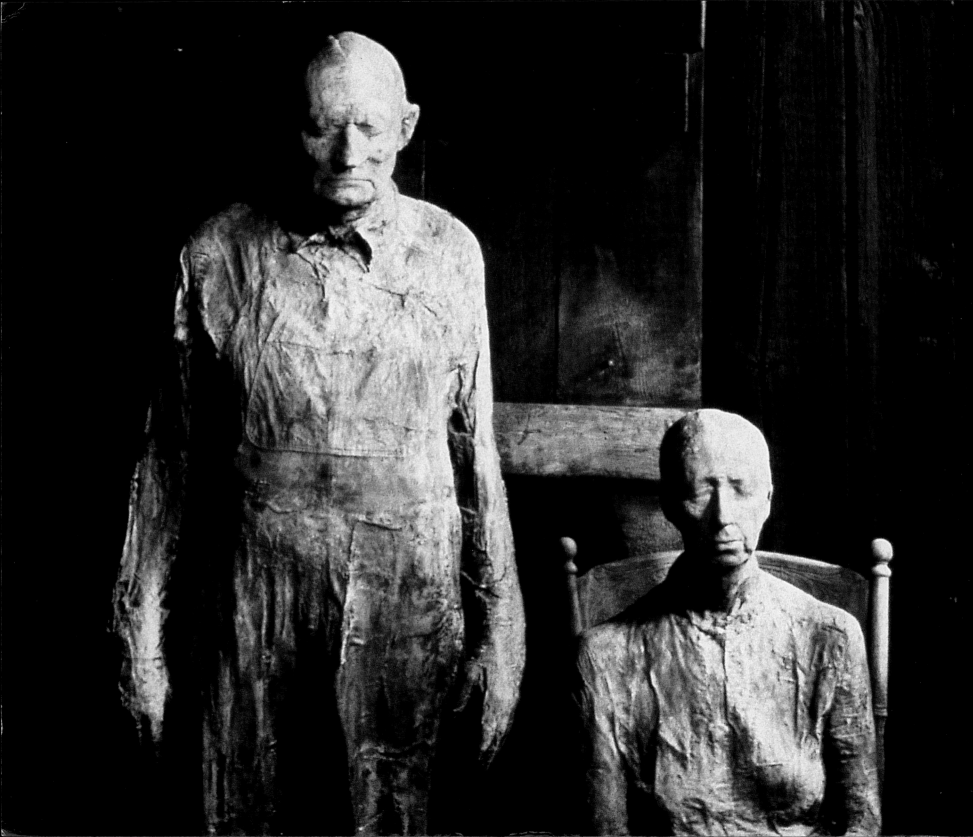

Checklist

1 **Portrait of Robert Scull**, 1963
Bronze with dark patina, Unique
22 x 6³/4 x 5¹/2 in. (55.9 x 17.1 x 14 cm)

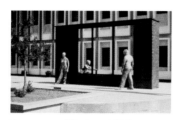

2 **Restaurant Window**, 1976, Bronze with dark
patina, brick, cement, steel, aluminum, tempered
glass and fluorescent light, 3 figures, Unique
120 x 192 x 96 in. (304.8 x 487.7 x 243.8 cm)
Plate 37

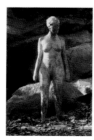

3 **Girl Standing in Nature**, 1976, Bronze with gray
patina, Edition of 3 and 1 artist's proof
Height: 67 in. (170.2 cm)
Plate 10

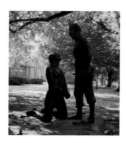

4 **In Memory of May 4, 1970: Kent State
(Abraham and Isaac)**, 1978, Bronze with
dark patina, Unique, 84 x 120 x 50 in.
(213.4 x 304.8 x 127 cm)
Plate 26

5 **Two Hands on Buckle**, 1978
Bronze with flesh and blue patina, Unique
11 x 14 x 5 in. (27.9 x 35.6 x 12.7 cm)

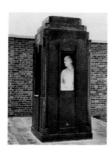

6 **Man in Toll Booth**, 1979, Bronze with white
patina, Unique, 108 x 43 x 43 in.
(274.3 x 109.2 x 109.2 cm)
Plate 22

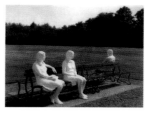

7 **Three People on Four Benches**, 1979
Bronze with white patina and metal benches
Edition of 3 and 3 artist's proofs
52 x 144 x 58 in. (132.1 x 365.8 x 147.3 cm)
Plate 34

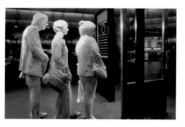

8 **The Commuters**, 1980, Bronze with white patina
3 figures, Unique, 84 x 72 x 96 in.
(213.4 x 182.9 x 243.8 cm)
Plates 24, 25

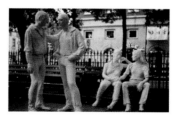

9 **Gay Liberation**, 1980, Bronze with white patina
4 figures, Edition of 2, 71 x 192 x 80 in.
(180.3 x 487.7 x 203.2 cm)
Plate 29

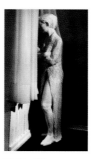

10 **Girl in Kimono Looking Through a Window**
1980, Bronze with white patina, glass and plastic
Unique, 96 x 43 x 30 in.
(243.8 x 109.2 x 76.2 cm)
Plate 30

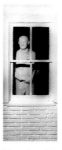

11 **Man Looking Through Window**, 1980
Bronze with white patina, Unique
96 x 37 x 28 in. (243.8 x 94 x 71.1 cm)
Plate 23

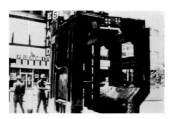

12 **The Steelmakers**, 1980, Bronze with dark patina
painted plastic and steel, 2 figures, Unique
216 x 240 x 180 in. (548.6 x 609.6 x 457.2 cm)
Plate 35, detail

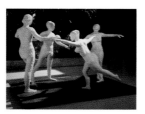

13 **The Dancers**, 1982 (plaster: 1971), Bronze with
white patina, 4 figures, Edition of 5 and 3 artist's
proofs, 56 x 71 1/4 x 106 in.
(142.2 x 181 x 269.2 cm)
Plates 4, 5

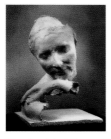

14 **The Holocaust**, 1982, Bronze with white patina
11 figures, Unique, 120 x 240 x 210 in.
(304.8 x 609.6 x 533.4 cm)
Plate 31

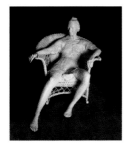

15 **Wendy with Chin on Hand**, 1982, Bronze with
white patina, Edition of 6 and 3 artist's proofs and
3 hors commerce, 14 1/4 x 10 1/8 x 8 1/2 in.
(36.2 x 25.7 x 21.6 cm)
Plate 18

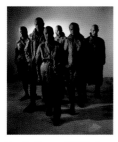

16 **Rush Hour**, 1983, Bronze with dark patina
6 figures, Edition of 5 and 3 artist's proofs
72 x 96 x 96 in. (182.9 x 243.8 x 243.8 cm)
Plate 12

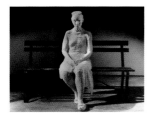

17 **Woman with Sunglasses on Bench**, 1983
Bronze with white patina, cast iron and metal
bench, Edition of 5 and 3 artist's proofs
51 x 60 x 32 in. (129.5 x 152.4 x 81.3 cm)
Plate 33

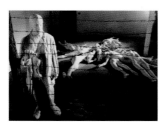

18 **Woman in White Wicker Rocker**, 1984
Bronze with white patina, Edition of 5 and 3 artist's
proofs, 42 x 33 x 50 in. (106.7 x 83.8 x 127 cm)
Plate 19

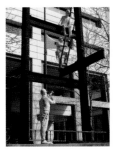

19 **The Constructors**, 1985, Bronze with white patina and steel beams, 3 figures, Unique
Height: 24 ft. (7.3 m)
Plate 27

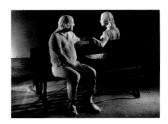

20 **Couple on Two Benches**, 1985, Bronze with white patina and metal benches, Edition of 5 and 2 artist's proofs, 51 x 62 x 62 in. (129.5 x 157.5 x 157.5 cm)
Plate 28

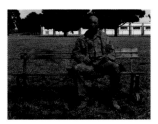

21 **Man on a Bench**, 1985, Bronze with dark patina and metal bench, Edition of 3 and 3 artist's proofs 54 x 48 x 40 in. (137.2 x 121.9 x 101.6 cm)
Plate 38

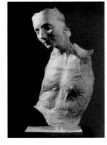

22 **Woman in Lace**, 1985, Bronze with white patina
Edition of 9 and 6 artist's proofs
26 x 15 x 7 in. (66 x 38.1 x 17.8 cm)
Plate 32

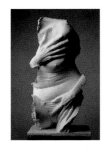

23 **Fragment: Venus Gesture**, 1986, Bronze with white patina, Edition of 9 and 3 artist's proofs
24 x 12 1/4 x 7 in. (61 x 31.1 x 17.8 cm)
Plate 9

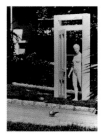

24 **Girl Looking Through Doorway**, 1987 (plaster: 1976), Bronze with white patina, wood door and frame, Edition of 3 and 1 artist's proof
96 x 42 x 24 in. (243.8 x 106.7 x 61 cm)
Plate 16

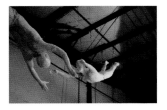

25 **Circus Acrobats**, 1988, Bronze with white patina
2 figures, Edition of 3 and 2 artist's proofs
72 x 144 x 20 in. (182.9 x 365.8 x 50.8 cm)
Plate 3

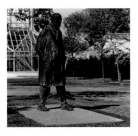

26 **Walking Man**, 1988, Bronze with dark patina
Edition of 5 and 2 artist's proofs
72 x 36 x 30 in. (182.9 x 91.4 x 76.2 cm)
Plate 17

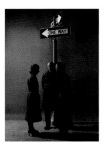

27 **Chance Meeting**, 1989, Bronze with dark patina and metal traffic signs, 3 figures, Edition of 6 and 3 artist's proofs, 123 x 41 x 55 in. (312.4 x 104.1 x 139.7 cm)
Plate 2

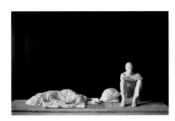

28 **The Homeless**, 1989, Bronze with white patina
2 figures, Unique, 96 x 144 x 52 in.
(243.8 x 365.8 x 132.1 cm)
Plate 36

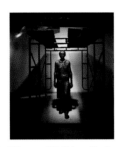

29 **Woman Walking Under Scaffold**, 1989
Bronze with dark patina, metal scaffold and wood
Unique, 96 x 120 x 64 in.
(243.8 x 304.8 x 162.6 cm)
Plate 21

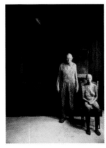

30 **Appalachian Farm Couple**, 1991, Bronze with
dark patina, Edition of 7 and 2 artist's proofs
108 x 108 x 53 in. (274.3 x 274.3 x 134.6 cm)
Plate 1

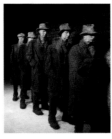

31 **Depression Breadline**, 1991, Bronze with dark
patina, 5 figures, Edition of 7 and 2 artist's proofs
108 x 148 x 36 in. (274.3 x 375.9 x 91.4 cm)
Plates 6, 7

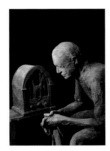

32 **Fireside Chat**, 1991, Bronze with dark patina
Edition of 7 and 2 artist's proofs
108 x 120 x 57 in. (274.3 x 304.8 x 144.8 cm)
Plate 8, detail

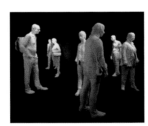

33 **Street Crossing**, 1992, Bronze with white patina
7 figures, Edition of 6 and 3 artist's proofs
72 x 192 x 144 in. (182.9 x 487.7 x 365.8 cm)
Plates 13-15

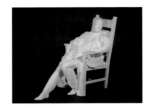

34 **Woman in Armchair**, 1994, Bronze with white
patina, Edition of 6 and 3 artist's proofs
47 x 31 1/2 x 52 in. (119.4 x 80 x 132.1 cm)
Plate 20

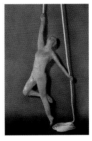

35 **Red Woman Acrobat Hanging From a Rope**
1996, Bronze with red patina and rope
Edition of 6 and 3 artist's proofs
100 x 40 x 12 in. (254 x 101.6 x 30.5 cm)
Plate 11

PLATE ACKNOWLEDGEMENTS

The Commuters, New York City Port Authority Bus Terminal, New York, NY

The Constructors, Commissioned by the State of New Jersey, installed at the Department of Commerce Building, Trenton, NJ

The Dancers, National Gallery of Art, Washington DC

Gay Liberation, Commissioned by the Mildred Andrews Fund, installed at Sheridan Square, Christopher Park, New York, NY

The Holocaust, Collection of San Francisco Arts Commission, Golden Gate Park, Mayor Dianne Feinstein's Committee For Memorial to Six Million Victims of the Holocaust, San Francisco, CA

The Homeless, Commissioned by the Mildred Andrews Fund, Cleveland, OH

In Memory of May 4, 1970: Kent State (Abraham and Isaac), John B. Putnam, Jr. Memorial Collections, Princeton University, NJ

Man in Toll Booth, Newark Museum, Newark, NJ

The Steelmakers, Commissioned by the Youngstown Area Arts Council, Youngstown, OH

Three People on Four Benches, PEPSICO Sculpture Garden, Purchase, NY

Restaurant Window, Commissioned by the Government Services Administration Art-in-Public-Places, installed at the Federal Office Building, Buffalo, NY

Walking Man, Collection Walker Art Center, Minneapolis, Gift of the AT&T Foundation and Julius E. Davis family in memory of Julius E. Davis, 1988, Minneapolis, MN

This catalogue was published on the occasion of the exhibition
GEORGE SEGAL: BRONZE
held at Mitchell-Innes & Nash, New York
April 23 – June 14 2003
Presented in association with The George and Helen Segal Foundation
and Carroll Janis Inc., New York

Publication © Mitchell-Innes & Nash/The George and Helen Segal Foundation/
Carroll Janis Inc.

Introduction © Carroll Janis
Essay © Joan Pachner

All work of art by George Segal © The George and Helen Segal Foundation/
Licensed by VAGA, New York, NY

Design: Dan Miller Design, New York
Printed in Hong Kong

ISBN 0-9713844-8-7

MITCHELL-INNES & NASH
1018 Madison Avenue New York NY 10021
Tel 212-744-7400 FAX 212-744-7401
Email info@miandn.com
Web www.miandn.com

Available through D.A.P/Distributed Art Publishers
155 Sixth Avenue 2nd Floor New York NY 10013
Tel 212-627-1999 Fax 212-627-9484

PHOTOGRAPHY

Noel Allum: page 55

Allen Finkelman: pages 12-13, 31, 42, 52-53, 58-61

Lisa Kahane: pages 8-9, 40, 41

Donald Lokuta photo © Donald Lokuta / Licensed by VAGA,
New York, NY: pages 2, 36, 79

Kevin Marr: page 47

Douglas Caulk: page 37 (right)

Mitchell-Innes & Nash are very pleased to present this catalogue, and the
exhibition it accompanies as our first collaboration with The George and Helen
Segal Foundation and Carroll Janis Inc. We would like to express our gratitude
to Helen Segal and family and Carroll Janis. We thank them for their support
and their many contributions to this venture. We would like to extend a special
thanks to Joan Pachner, whose essay provides an insightful and thoughtful
contribution to this publication. In addition, we are very grateful to Jeanie Deans
for her assistance in the research and coordination of this project.